paige tate & CO.
www.paigetate.com

Published in 2016 by
Paige Tate & Co.
An Imprint of PCG Publishing LLC
3610 Avenue B
San Antonio, TX 78209
email: reagan@paigetate.com
www.paigetate.com

ISBN: 978-1944515096

Printed in China

ABOUT THE AUTHOR

Sarah is a Jesus-loving, Instagram-ing, wine-drinking semi-hoarder who loves anyone who can make her laugh. A day in her life looks like taking a crazy number of photos, dancing in the garage while packaging up orders, and cuddling with her pups. She is the sassy lady behind Chalkfulloflove, a hand-lettered goods shop started in 2013, and the founder of The Creative Counsel Conference. She went to school for graphic design and is a self-taught hand letterer and shop owner. Everything she creates is hand lettered by her in Austin, Texas. You can find more about her and her work at chalkfulloflove.com.

So, you want to learn to letter...

This book is full of fun letters, detailed instructions and super cute projects!

What's inside

LETTER BASICS

LETTER BASICS

BASICS OF TYPE.

DESCENDER

Extends below the baseline and can be found in g, y, p, q and f.

DOWNSTROKE

The downward stroke of the letter, which is the thickest part.

HAIRLINE

Any upstrokes of calligraphy letters can be referred to as hairline strokes. They are the thinnest part of your letter.

CROSS STROKE

The line that crosses through your letters. Think capital letters A, H, F and the lowercase letter t. These can be as basic or as decorative as you like!

THE HOW-TO

In traditional calligraphy you apply pressure with each downstroke of the pen, which creates thickness. My style of lettering is sometimes referred to as "faux calligraphy" because I reproduce the traditional calligraphy effect without using the traditional calligraphy pen.

I draw out my letter with pen, pencil, or chalk, and then go back to create a thicker downstroke by drawing a second connecting line and filling it in. When using thicker pens like chalkboard and paint pens, this effect can be reproduced by outlining the downward strokes.

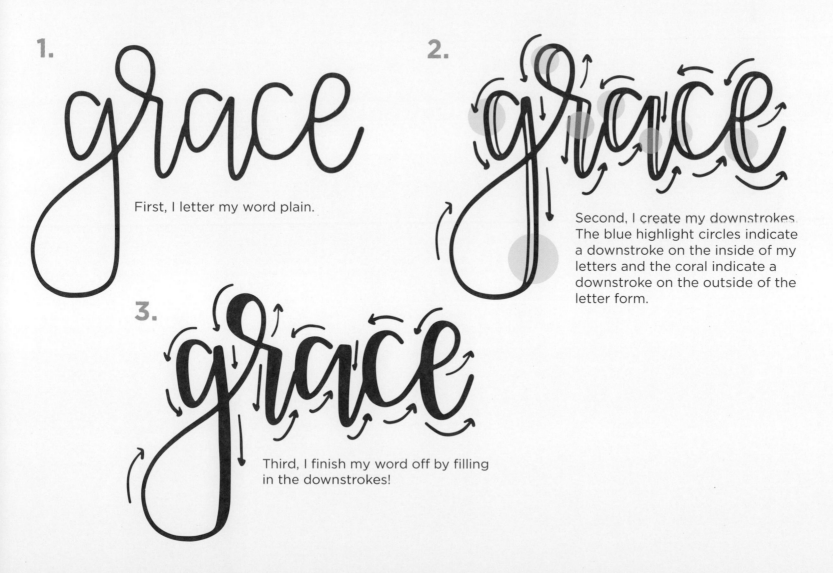

1. *grace*

First, I letter my word plain.

2. *grace*

Second, I create my downstrokes. The blue highlight circles indicate a downstroke on the inside of my letters and the coral indicate a downstroke on the outside of the letter form.

3. *grace*

Third, I finish my word off by filling in the downstrokes!

THE HOW-TO

Everyone eventually develops their own style of lettering. You start out by mimicking a style you like and then you put your own twist on it. Right now, I am really loving rounder letters with exaggerated curves and thick downstrokes. Lettering is all about learning the muscle movements required to produce each letter and keeping control of your pen. Trust me, my day-to-day handwriting looks nothing like this. You do not have to have nice handwriting to be a good letterer!

Tips + Tricks:

1. Whether it's lettering, faux calligraphy, brush calligraphy, or traditional calligraphy the key to becoming great at it, is to practice a lot! This will most likely not come natural to you, but if you devote time to it every day or week you will see yourself improve so much! I look back on projects I created when I first started Chalkfulloflove, and I am so embarrassed of them! But, I am also amazed at how far I have come in a few years. You can do it!

2. Try out all sorts of different pens! In the next chapter you will find some of my favorite tools. Don't limit yourself to just those! Try out thick, thin, brush, and broad tips!

3. If you find yourself getting burnt out or even experiencing cramping in your hand (I know, it hurts!), I always like to step back and take a break. You will take the fun out of lettering if you over do it!

4. Finding your own style is what will set you apart and make you more successful. Once you understand and master the basic movements and shapes, it becomes easy to manipulate the letter forms to create different styles. Do you like letters that dance? Maybe you like large flourishes! Do you like it when they are all even and perfect? Gather inspiration from letterers and calligraphers you admire and try to find a style that speaks to you!

MY FAVORITE TOOLS

MY FAVORITE TOOLS

The beauty of faux calligraphy is that you can use any kind of pencil or pen. That is a definite plus of faking it! Personally, I am most comfortable sketching my entire design in pencil. Nothing fancy – I use a .7 lead mechanical pencil, just like I did in high school. Then I trace over that with a Micron pen. Once I finish with the pen, I go back and erase any traces of pencil.

PENCILS.

These are a super-sophisticated faux calligraphy tool. Just kidding! Any pencil will do, but I tend to prefer thicker lead because I find it flows nicer.

MICRON PENS.

You can tell by the name of this particular pen that the point is very small. These pens use archival ink and are known for their smooth, flowing writing. This is definitely my day-to-day pen for the majority of my designs. It took some major getting used to, but once mastered, I found it to be my most versatile pen! The Micron is all about control. You may see shaky lines at first, and that's okay! Part of mastering your letter shapes is learning to flow with the pen. Micron pens are made by the brand Pigma and can be purchased at your local craft store or on Amazon. I recommend getting the six-piece set and determining your favorite sizes. I personally love the 02, 05, and 08.

MY FAVORITE TOOLS

ART ERASER.

If you choose to draw your design out in pencil like I do, I recommend you grab yourself a nice art eraser!
I personally use a Factis OV 12. You'll notice that pencil lead is very messy and having this handy will be a life saver!

HIGH QUALITY PAPER.

The quality of your paper is easy to overlook, but you'll regret it if you use cheap, thin paper. Starting with high quality paper will help you when you digitize your piece. I tend to use paper with an 80 lb. or 110 lb. cover weight. You can buy this at any craft store, office supply store or on Amazon.

SHARPIES.

If someone is struggling with the Micron, I often recommend they switch to a Sharpie. This is a great tool to start with when you are first learning! It is a thick point and is easier to control than Micron pens. Just your standard black Sharpie will work great! They can be purchased at any craft store or on Amazon!

MY FAVORITE TOOLS

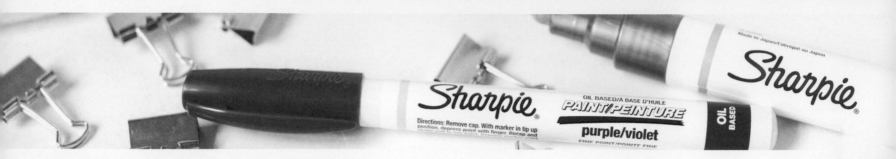

PAINT PENS.

Paint pens can add color and metallic fun to your project! Some of my favorite brands are oil- and water-based Sharpies and Craftsmart pens. I used to create a lot of gold-on-white custom pieces when I first started, and paint pens helped me achieve that! Paint pens will write very similarly to a Sharpie, but have a tendency to bleed and will require drying time. They can be purchased at any craft store or on Amazon!

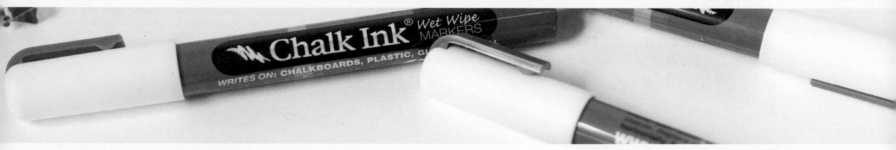

CHALK PEN.

Because I love working with chalkboards (hence the name Chalkfulloflove) chalkboard markers are my first love. My favorite brand is Chalk-Ink – I prefer the fine point but all of them work great on most chalk surfaces! The drawback of Chalk-Ink markers is that when erased, they may leave a "ghost" of your lettering or illustration. This can easily be removed with a Mr. Clean Magic Eraser. Chalk-Ink markers can be purchased straight from their website or Amazon!

TRADITIONAL CHALK.

Traditional chalk has a thicker and duller point than anything else I have mentioned, but it can be manipulated as you draw with it. I have a chalkboard wall in my home and I love to illustrate and letter with traditional chalk. You get the most authentic chalkboard look when you are working with traditional chalk.

LETTER DRILLS

Trace the letter shapes by following the [arrows,]
then use the space to the right to pract[ice.]

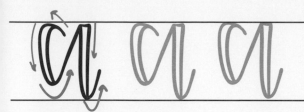

LETTER DRILLS

STEP 1

LETTER DRILLS STEP 1

Trace the letter shapes by following the arrows,
then use the space to the right to practice on your own!

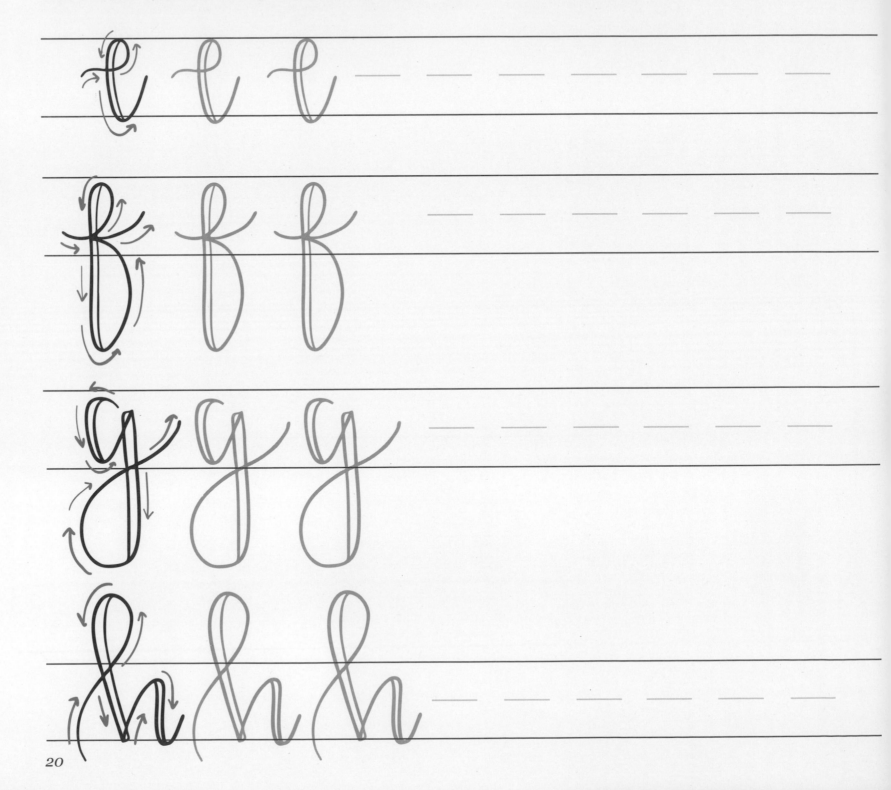

LETTER DRILLS STEP 1

Trace the letter shapes by following the arrows,
then use the space to the right to practice on your own!

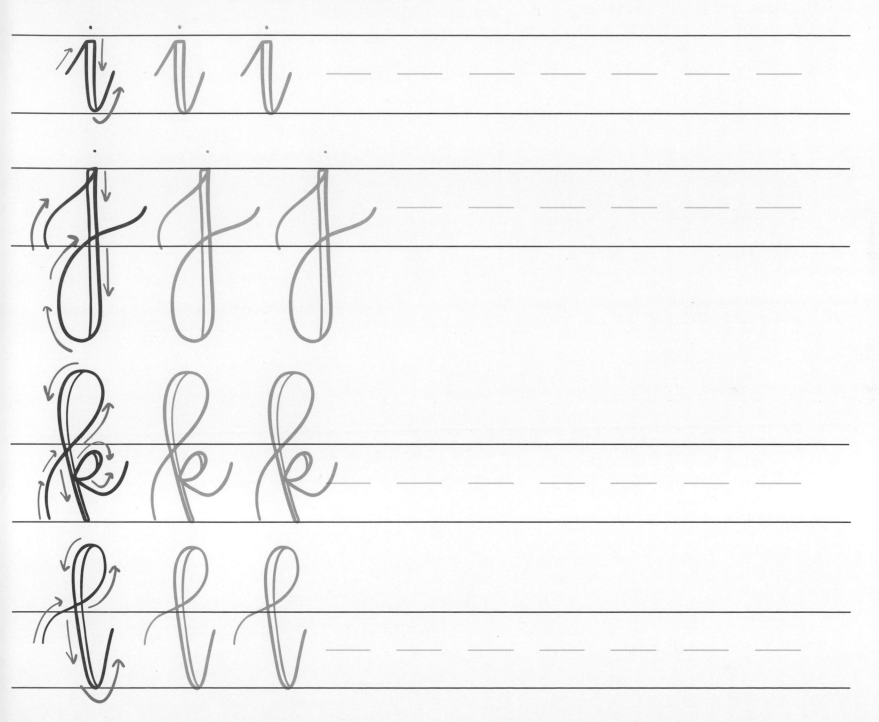

LETTER DRILLS STEP 1

Trace the letter shapes by following the arrows,
then use the space to the right to practice on your own!

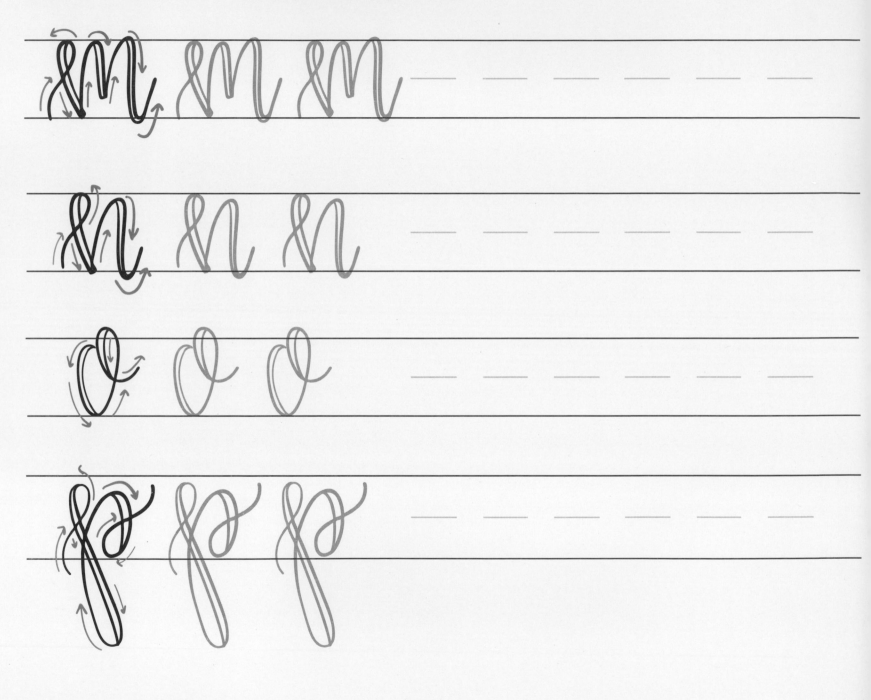

LETTER DRILLS STEP 1

Trace the letter shapes by following the arrows,
then use the space to the right to practice on your own!

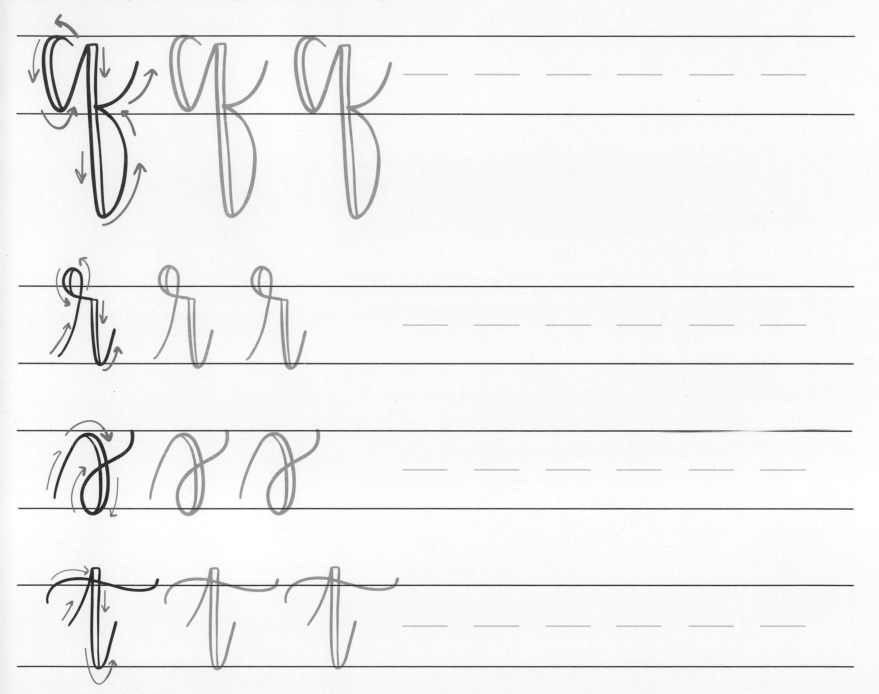

LETTER DRILLS STEP 1

Trace the letter shapes by following the arrows,
then use the space to the right to practice on your own!

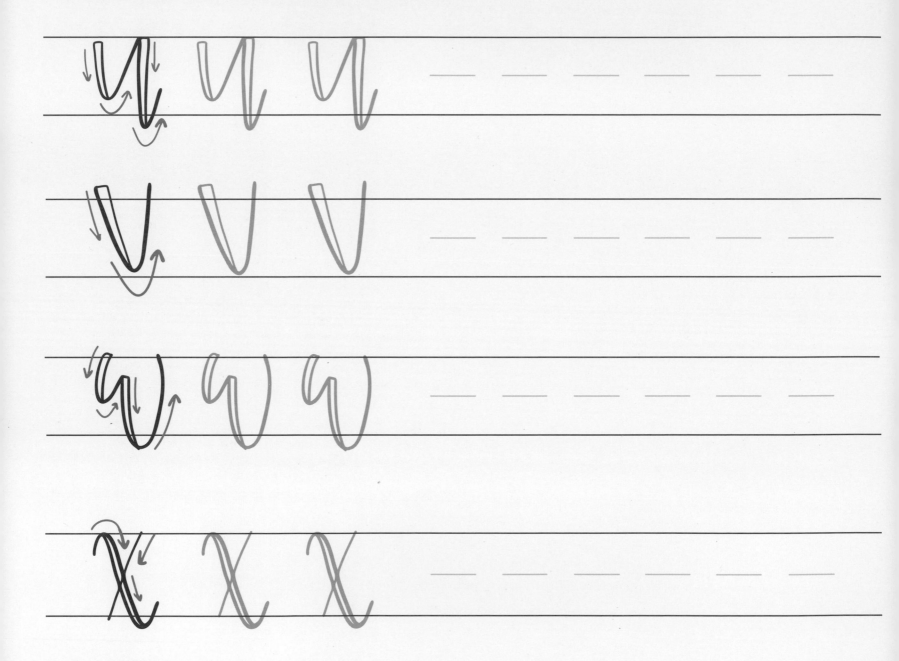

LETTER DRILLS STEP 1

Trace the letter shapes by following the arrows,
then use the space to the right to practice on your own!

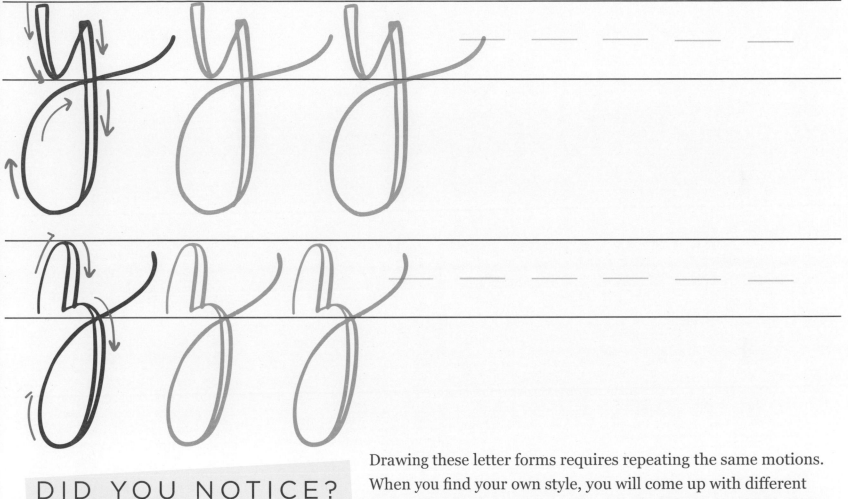

DID YOU NOTICE?

Drawing these letter forms requires repeating the same motions. When you find your own style, you will come up with different shapes that set your letters apart. I particularly love the big fancy loops on the letters m, n, p,r, h, b and k. If you don't like the way they look or feel, that's fine— give it another shot without the loops! Another repeating shape is the rounded face, like you see on the a, d, g, and q. You will notice that your i and your t start in a similar way as well! Once you get the repeating shape down, mastering one letter turns into mastering many! This fun new skill will most likely not come to you overnight! It took me about a year and a half to finally feel like I had mastered my own unique letter forms. I am not saying this to discourage you by any means, but to encourage you to not give up! Lettering takes time and a whole lot of practice! The more time you put into mastering letters, the more comfortable you will feel when you start designing. So, grab your pen and start again!

LETTER DRILLS STEP 1

Trace the letter shapes by following the arrows,
then use the space to the right to practice on your own!

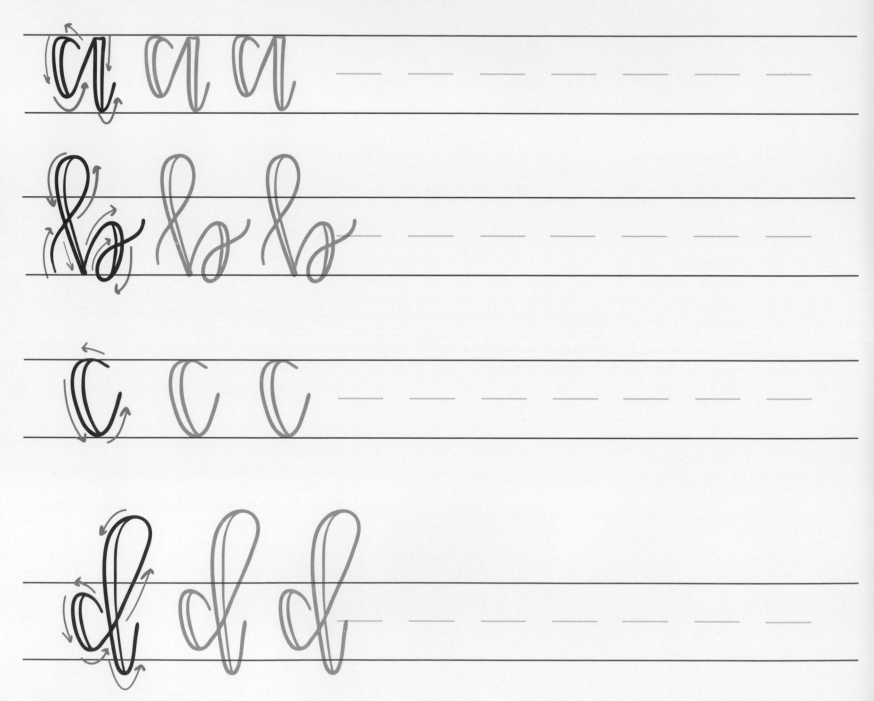

LETTER DRILLS STEP 1

Trace the letter shapes by following the arrows,
then use the space to the right to practice on your own!

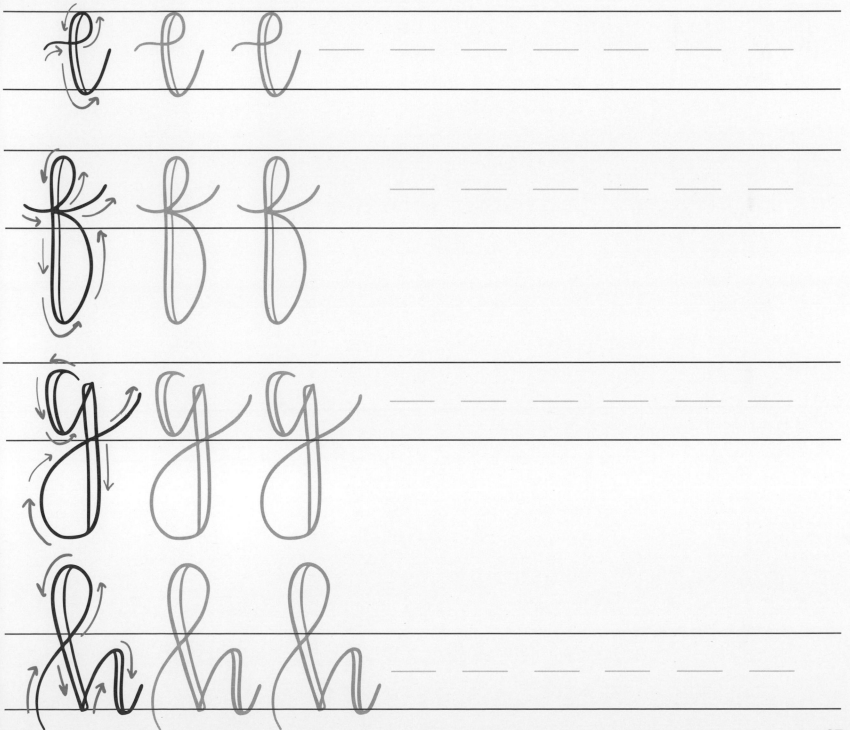

LETTER DRILLS STEP 1

Trace the letter shapes by following the arrows,
then use the space to the right to practice on your own!

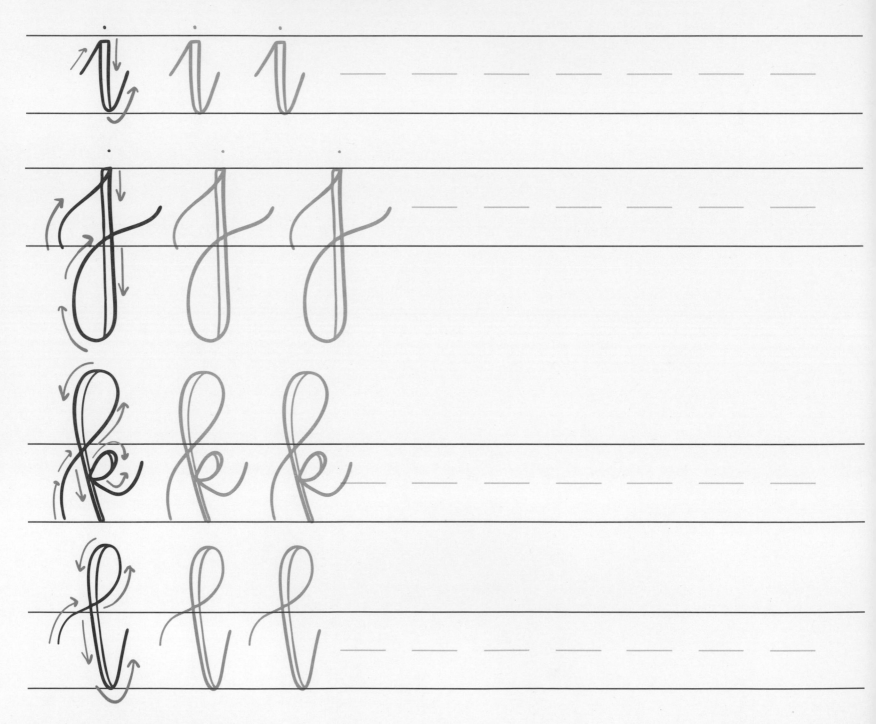

LETTER DRILLS STEP 1

Trace the letter shapes by following the arrows,
then use the space to the right to practice on your own!

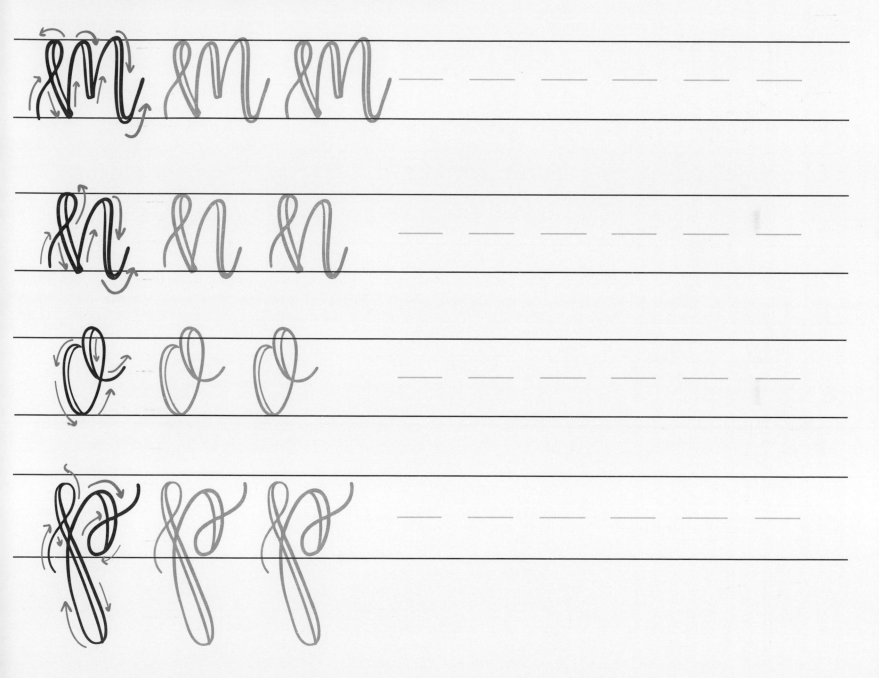

LETTER DRILLS STEP 1

Trace the letter shapes by following the arrows,
then use the space to the right to practice on your own!

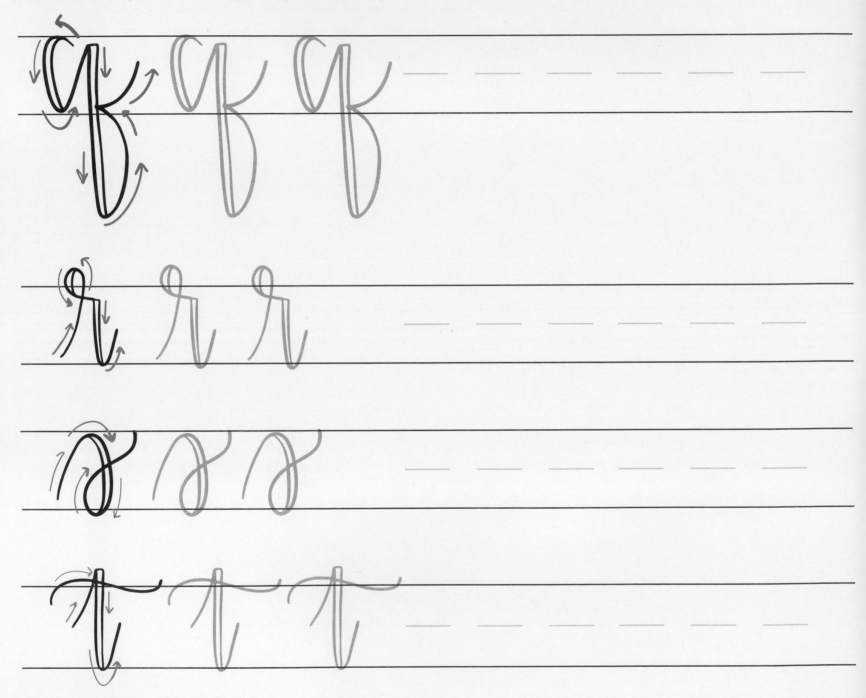

LETTER DRILLS STEP 1

Trace the letter shapes by following the arrows,
then use the space to the right to practice on your own!

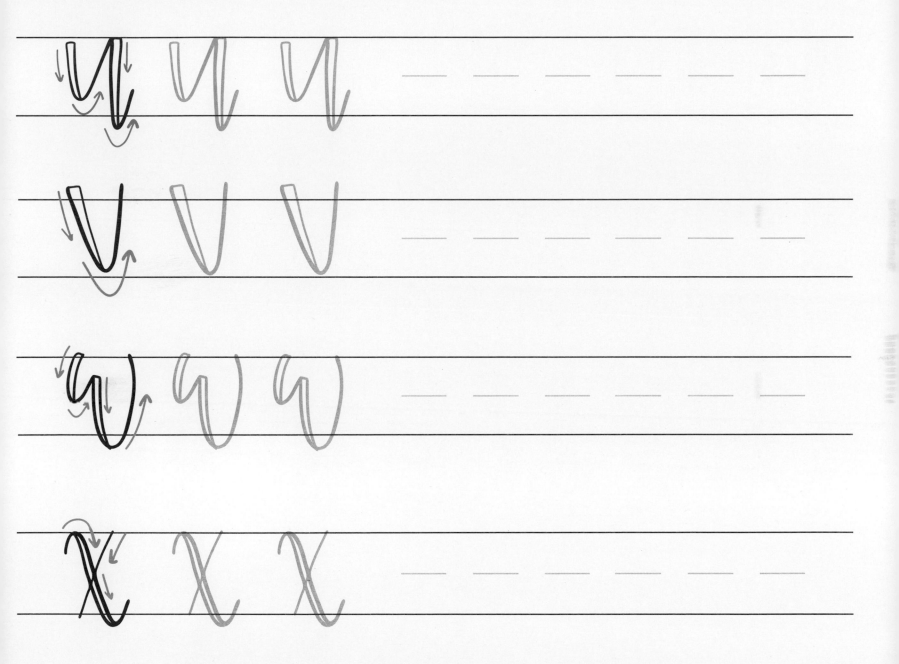

LETTER DRILLS STEP 1

Trace the letter shapes by following the arrows,
then use the space to the right to practice on your own!

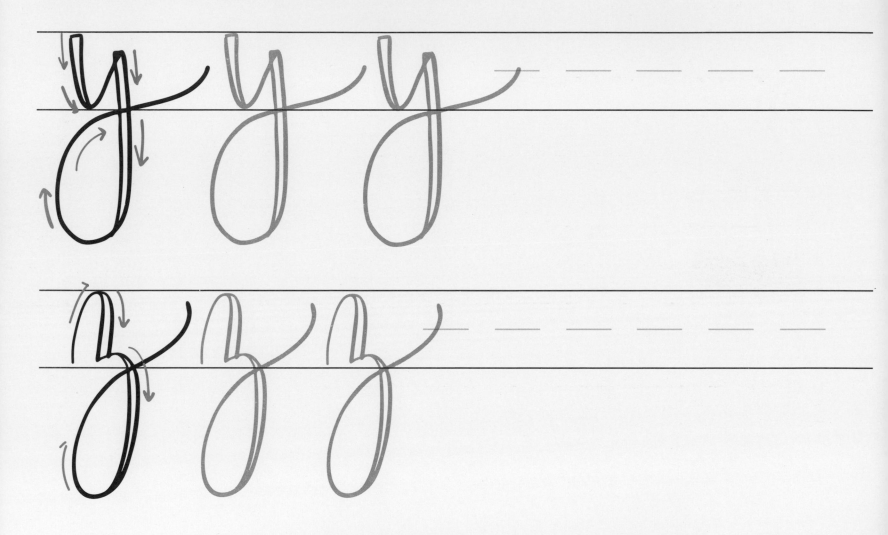

LETTER DRILLS

STEP 2

LETTER DRILLS STEP 2

Practice on your own, and fill in your downstrokes!

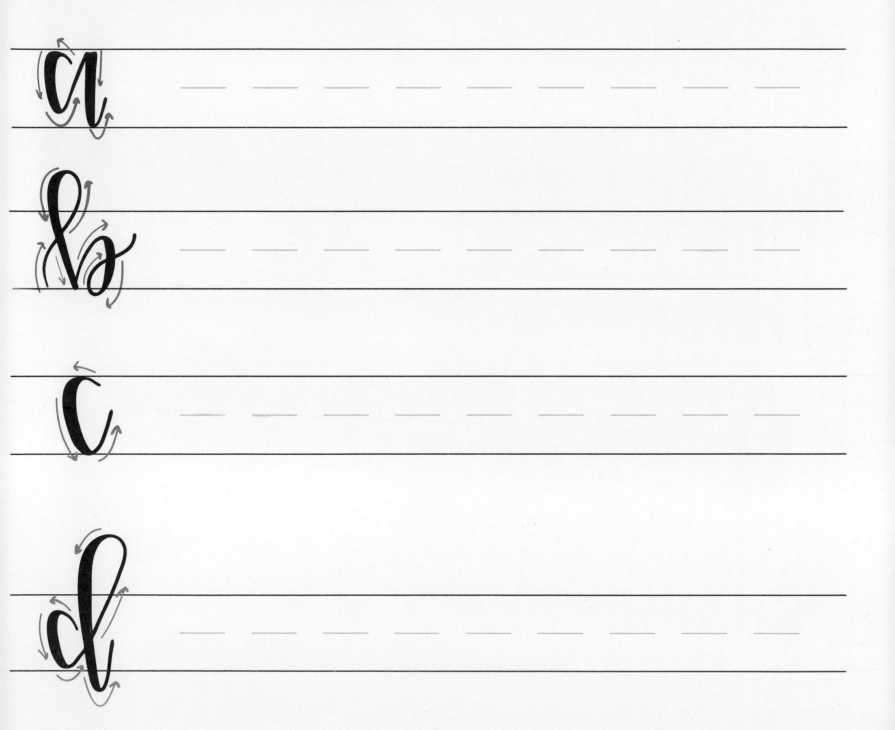

LETTER DRILLS STEP 2

Practice on your own, and fill in your downstrokes!

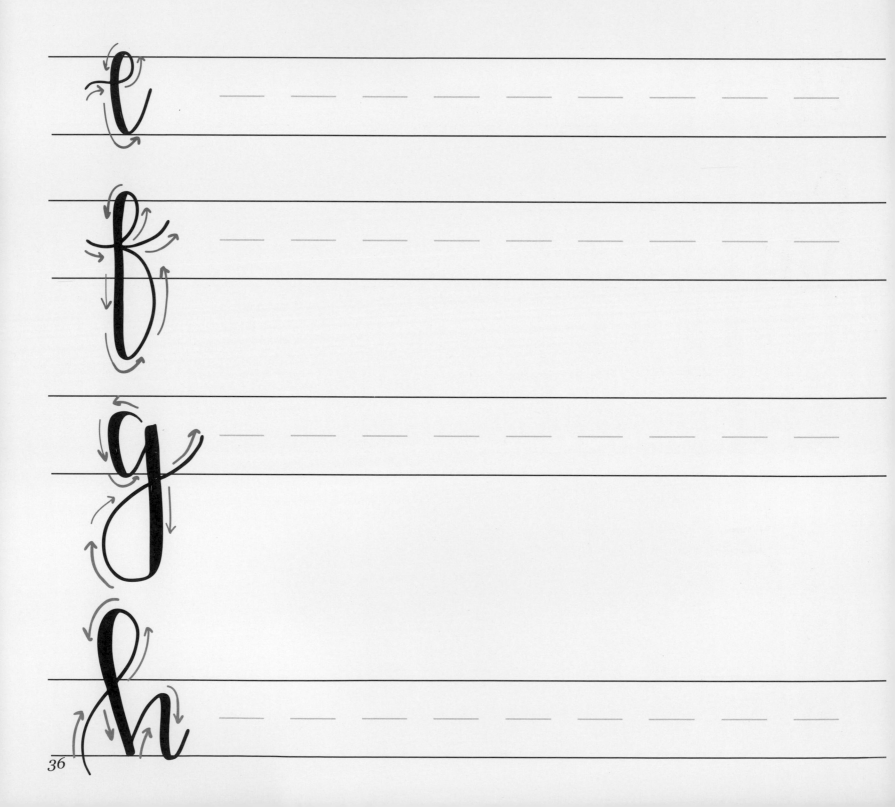

LETTER DRILLS STEP 2

Practice on your own, and fill in your downstrokes!

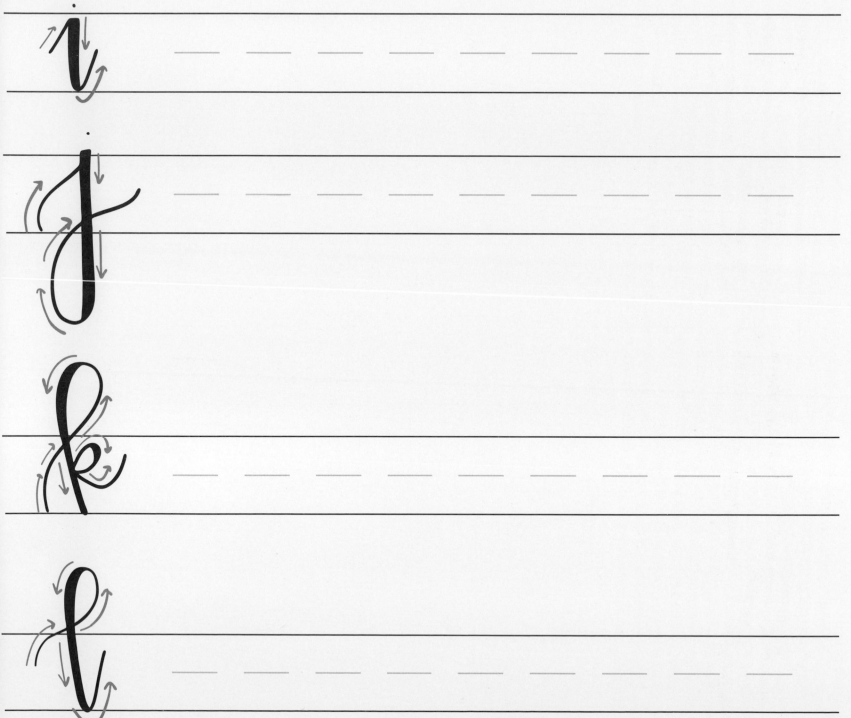

LETTER DRILLS STEP 2

Practice on your own, and fill in your downstrokes!

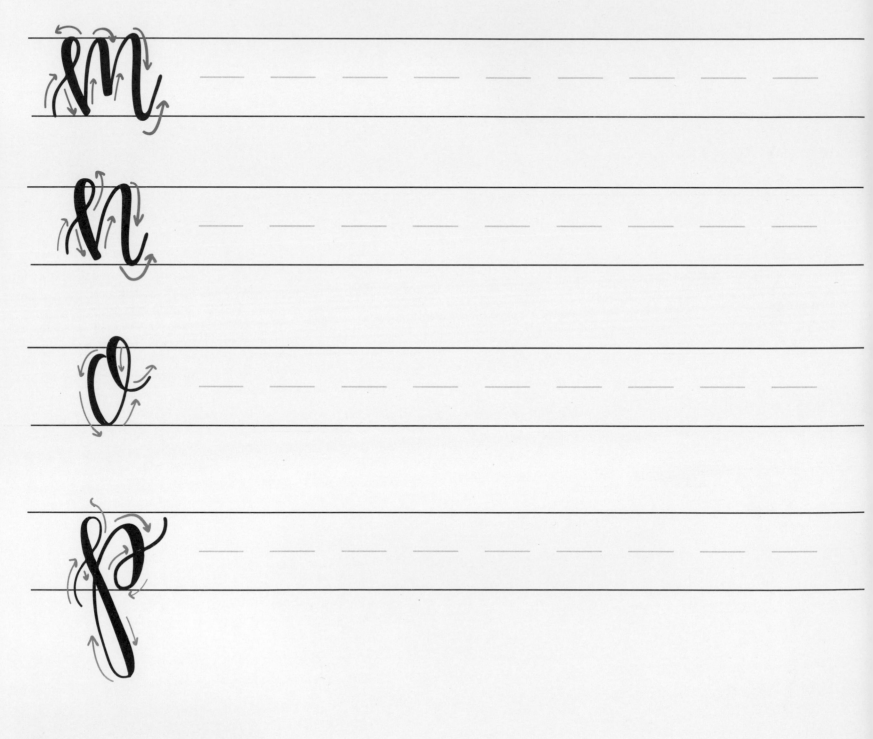

LETTER DRILLS STEP 2

Practice on your own, and fill in your downstrokes!

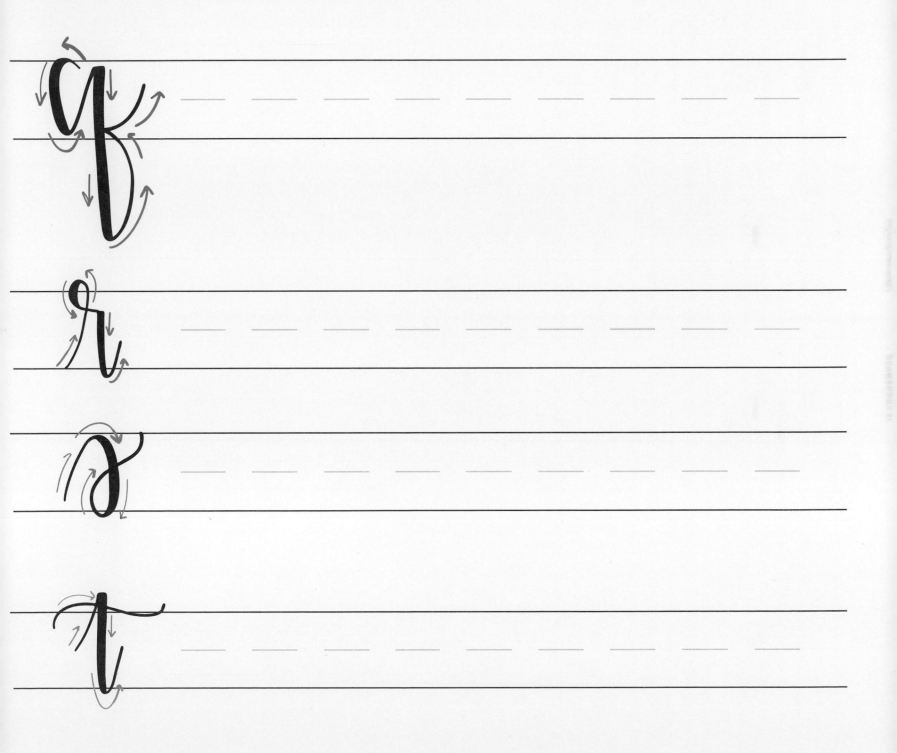

LETTER DRILLS STEP 2

Practice on your own, and fill in your downstrokes!

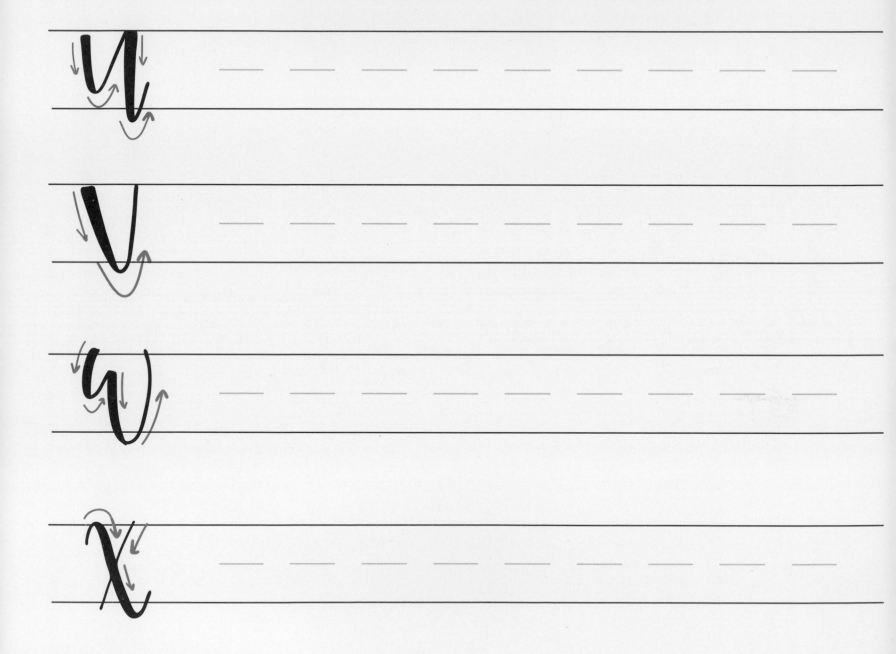

LETTER DRILLS STEP 2

Practice on your own, and fill in your downstrokes!

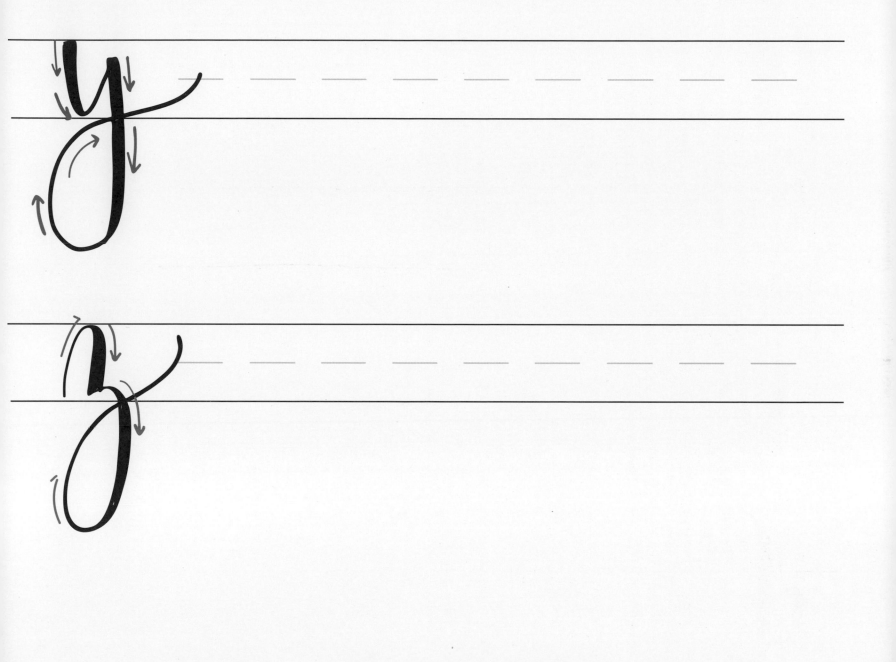

Practice on your own, and fill in your downstrokes!

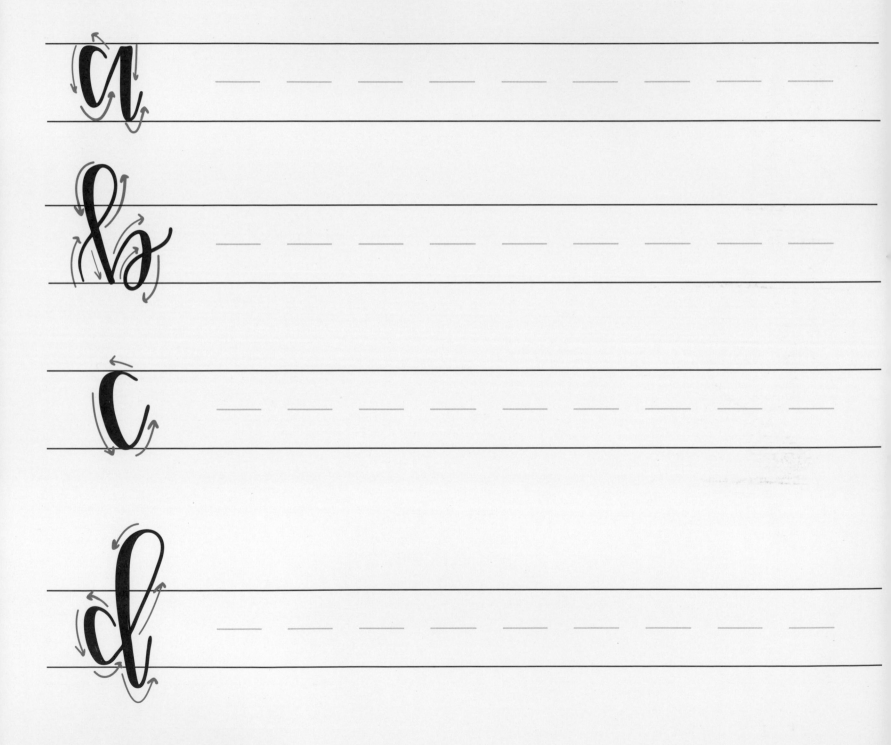

LETTER DRILLS STEP 2

Practice on your own, and fill in your downstrokes!

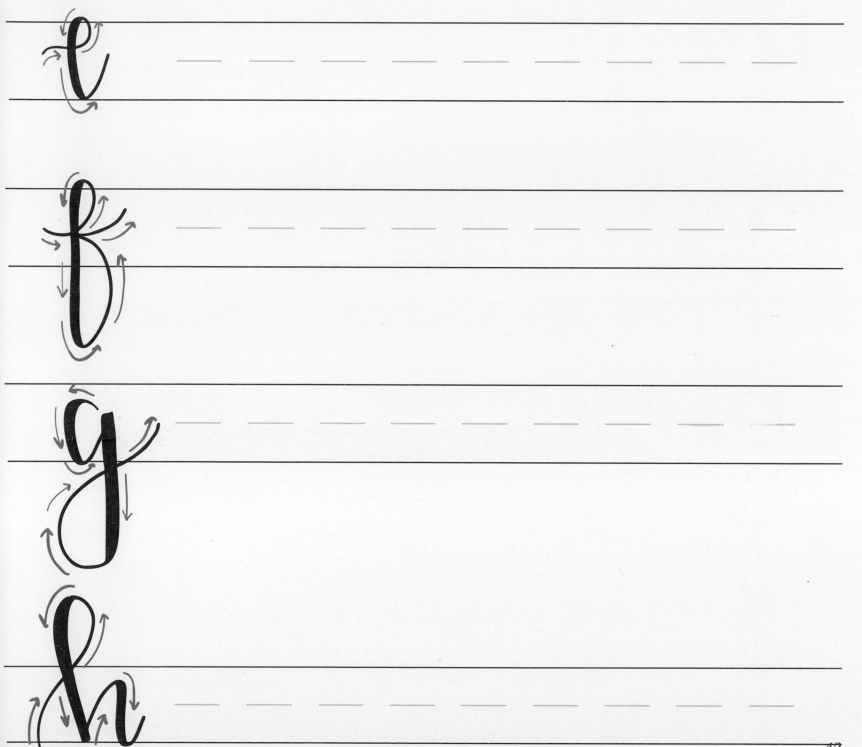

LETTER DRILLS STEP 2

Practice on your own, and fill in your downstrokes!

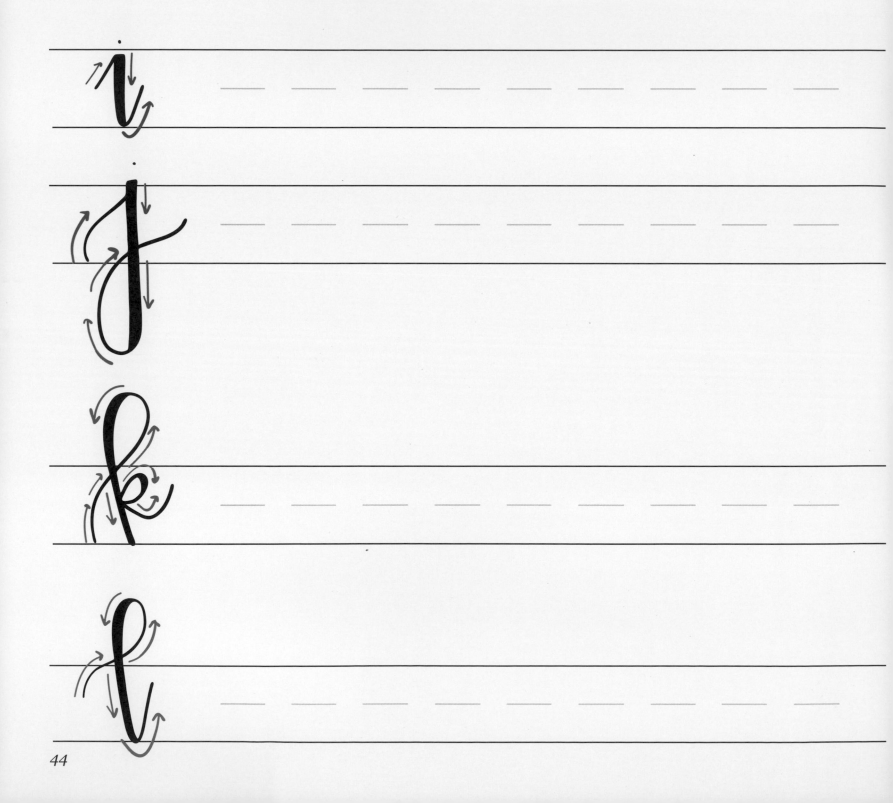

LETTER DRILLS STEP 2

Practice on your own, and fill in your downstrokes!

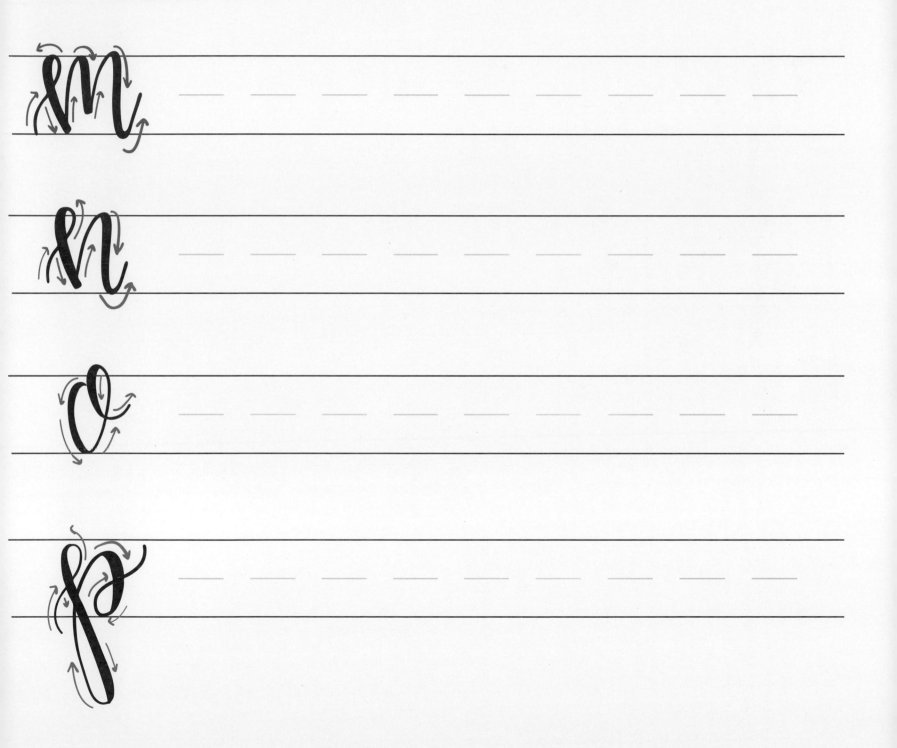

LETTER DRILLS STEP 2

Practice on your own, and fill in your downstrokes!

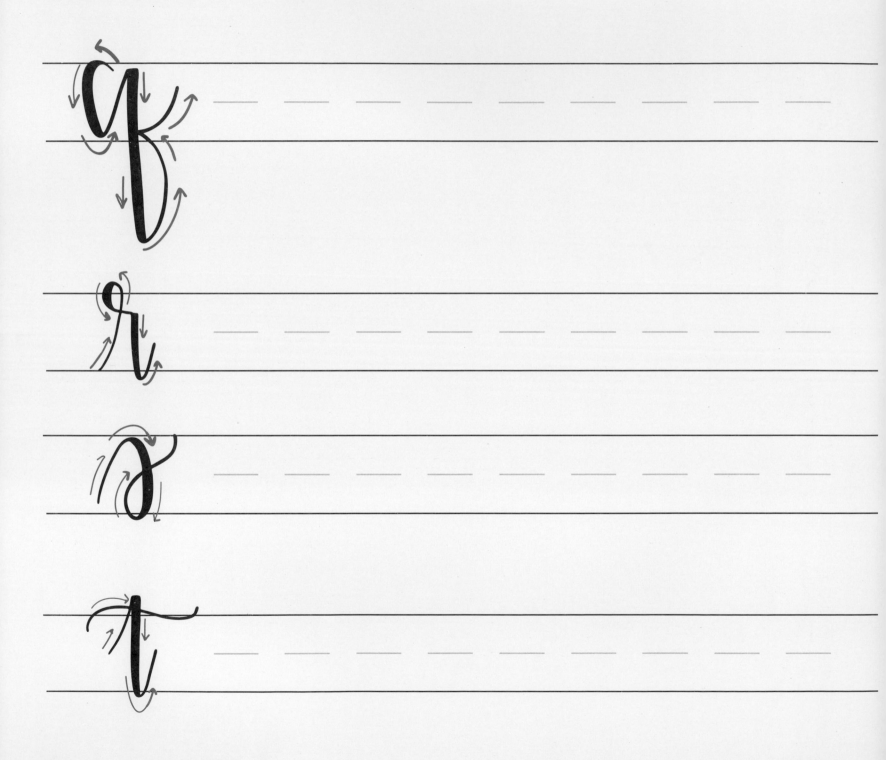

LETTER DRILLS STEP 2

Practice on your own, and fill in your downstrokes!

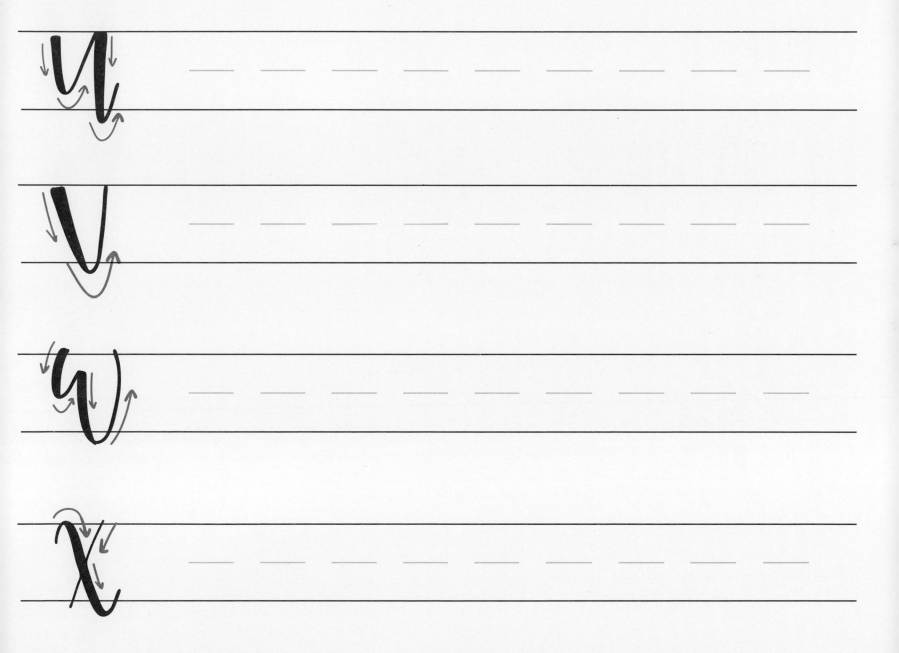

LETTER DRILLS STEP 2

Practice on your own, and fill in your downstrokes!

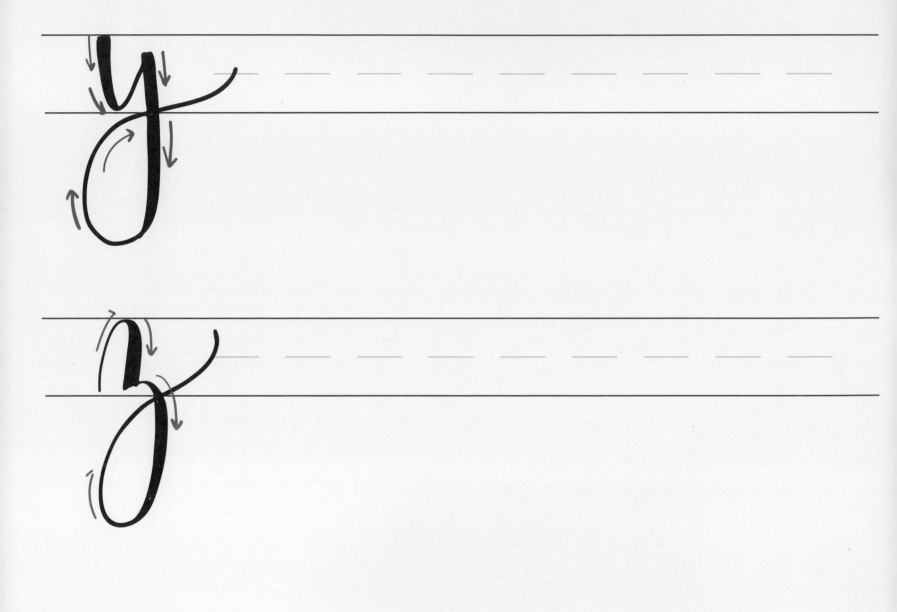

CONNECTING
THE LETTERS

CONNECTING THE LETTERS

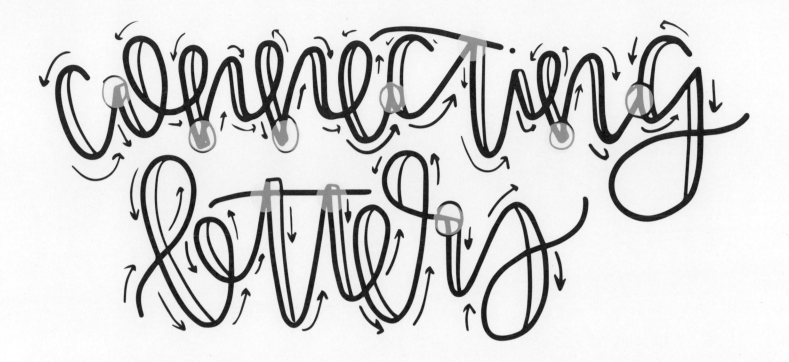

Connecting your letters is one of the most difficult parts of hand lettering to master. It's important to think of each letter as it's own separate shape. There will be portions of words where you will have to stay fluid and connect these shapes without lifting your pen. To connect certain letters you will notice that I chose to lift the pen, indicated by the highlight circles. When a letter is followed by a curved faced letter, like "a", "c", or "g", end your letter with a long tail and start the next one to connect. You can see where I stopped a letter and started the next one wherever there is a highlight circle.

LIFTING THE PEN

Follow along as I write the word "cursive"

1.

Starting with my first letter C I was thinking about what I will connect with, which is the U with a round face, so I made my C's tail longer so that it could meet almost to the top of my U letterform.

2.

When I drew the connection between the U to the R I kept my pen fluid and on the paper so that I got the nice curve at the bottom of the U and a loop at the top of the R.

3.

At the top of my downstroke for my R, I lift my pen and start the connection to the S.

4.

The same lift of my pen happens at the downstroke of my I, you can see it looks identical to the downstroke of the R.

5.

I stay fluid between the I and the V to get those nice curves at the bottom of each letterform.

6.

Finally, I pick up my pen to start my E letterform so that it hits the end of my V!

Do you see how we got from this? to this?

CONNECTING THE LETTERS

A great way to practice connecting letters is to go through the alphabet. You will start to notice the pattern that was stated earlier. Following the general rule of picking up your pen and starting your next letter when it has a rounded face.

abcdefghi

TRICKY TRANSITIONS

Illustrated below, you will see some of the hardest connecting letter transitions! They usually show up when you are linking two of the same letter or two loopy letters together. For example: On "LL" I kept my pen steady and fluid, never lifting it from the paper while I drew two loops back to back. You can also notice when I have two "L's" together I tend to make the second one smaller so that I don't run them into each other at the top. Just like your letterforms, these fluid transitions will take time to master. It is all about getting your muscle memory down.

ll pp el er ap

Use the space below to practice drawing the L loops and E loops over and over without lifting your pen. When I tried, I could get 5 loops in a row before I had trouble moving my hand to the right and staying fluid.

lllll

lllll

Use the space below to practice connecting your letters!

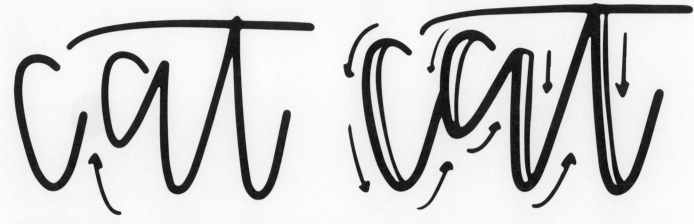

Pick up your pen here and start the next letter.

Practice here:

Use the space below to practice connecting your letters!

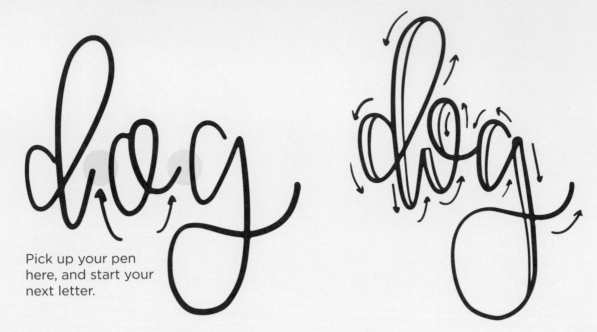

Pick up your pen here, and start your next letter.

Practice here:

Use the space below to practice connecting your letters!
Ready for a bigger challenge? I think you are!

congrats

Pick up your pen
here, and start your
next letter.

congrats

Practice here:

Use the space below to practice connecting your letters!

celebrate

Pick up your pen here and start
the next letter.

celebrate

Practice here:

Use the space below to practice connecting your letters! Remember those tricky transitions we talked about? Let's practice some.

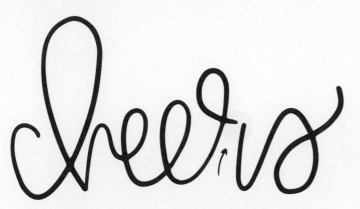

Pick up your pen here and start the next letter.

Practice here:

Use the space below to practice connecting your letters! Remember those tricky transitions we talked about? Let's practice some.

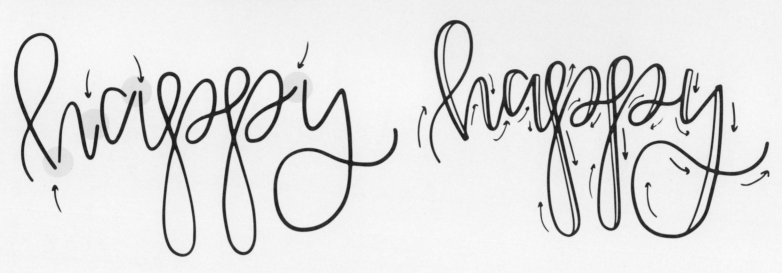

Practice here:

FINAL THOUGHTS

I want you to recognize that while connecting, some of your letters will give you the opportunity to lift your pen if necessary without compromising your design. This can happen with the letter A, like you see in the above example of the word "happy." Lifting my pen at the connecting point of the downstroke eased my hand and prepared me for the fluid double P's. This also happens with the letters R and N in "cheers" and "congrats."

MAKE THOSE LETTERS DANCE

A big trend right now is a super-flowy modern look. This can be achieved by making your letters "dance." Try to ignore the baseline, dip your tails, throw in some loops, make some letters smaller than others, exaggerate your descenders and ascenders, and try to be as fluid as possible. That sounds easy, right? Probably not! These techniques are definitely advanced and will take some major time to master. Let's break it down!

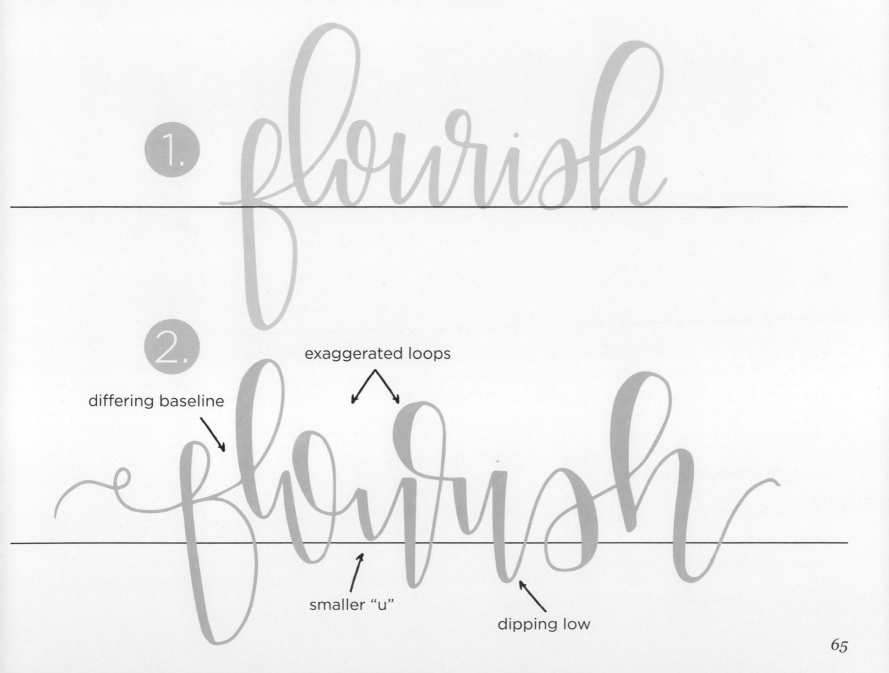

1. flourish

2. flourish

differing baseline

exaggerated loops

smaller "u"

dipping low

Let's break down another example!

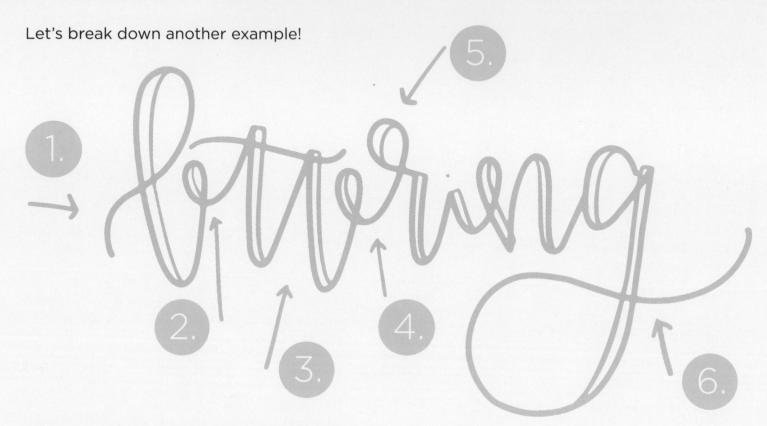

1. I started this word off with a little flourish!

2. The E then gets lifted from the original baseline and also decreased in size.

3. The two T's together are sitting on different baselines.

4. I brought the baseline up once again and decreased the size of the E.

5. I exaggerated my R loop.

6. I exaggerated my G loop and ended with a small flourish.

Making the letters dance will come more naturally to some than to others, don't be discouraged if you are having trouble with the concept. Once you write the same word over and over, you will start to notice different ways you can change it up! There is no right or wrong way to making them dance!

DANCE IT OUT

Use this space to practice different words + ways to make your letters dance!

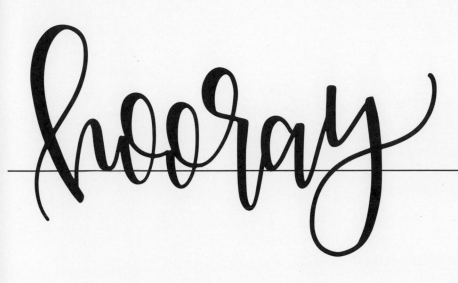

DANCE IT OUT

Use this space to practice different words + ways to make your letters dance!

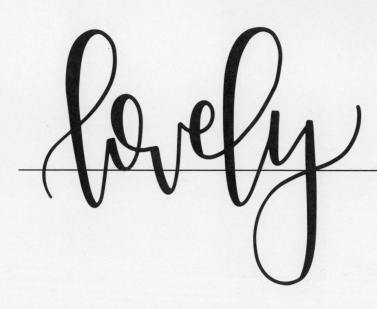

Use this space to practice different words + ways to make your letters dance!

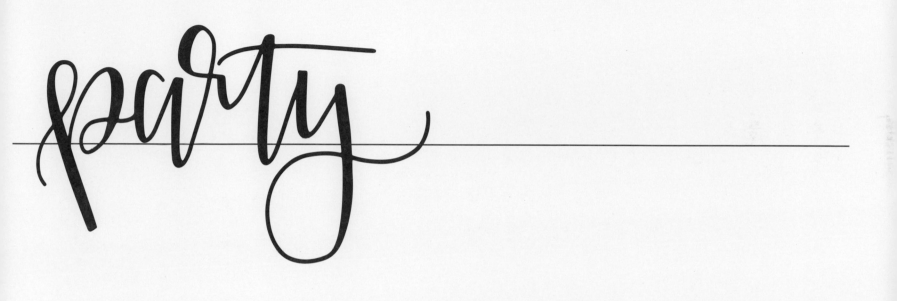

MIXING
AND MATCHING

MIXING AND MATCHING

Mixing and matching different types of lettering can really add to your final design. My favorite kind of typeface to mix with my letters is a thin sans serif. I think the two complement each other well. If you have a thinner, flowy style, a thicker serif font would match nicely. They don't necessarily have to be exact opposites, either. It is really what you are trying to say with your design. Try to evoke a feeling and go with it. To me, serif is a serious typeface. It is level, easy to read, and uniform. Because sans serif designs are sillier, I tend to draw a sans serif to go with playful designs. On the following pages you will see examples of the different alphabets that I use in my designs.

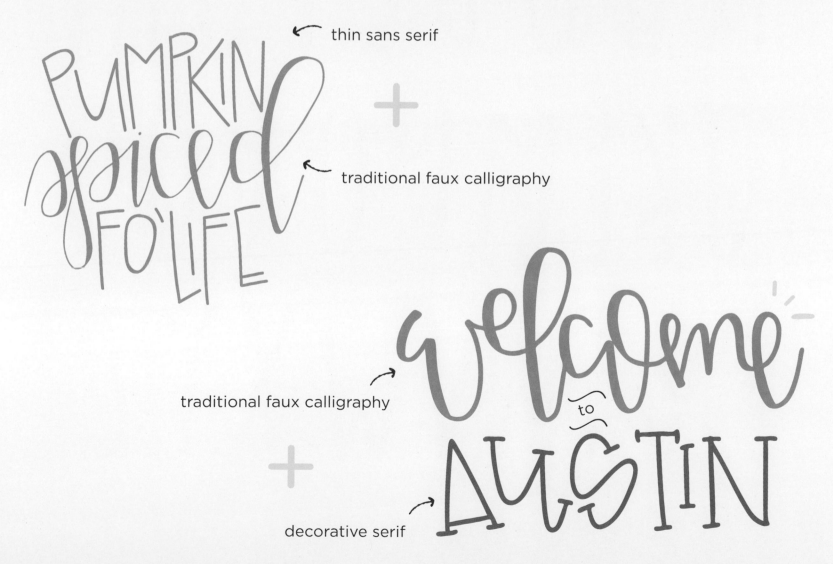

thin sans serif

traditional faux calligraphy

traditional faux calligraphy

decorative serif

ABCDEFGHI
JKLMNOPQR
STUVWXYZ

A B C D E F G H
I J K L M N O P
Q R S T U V
W X Y Z

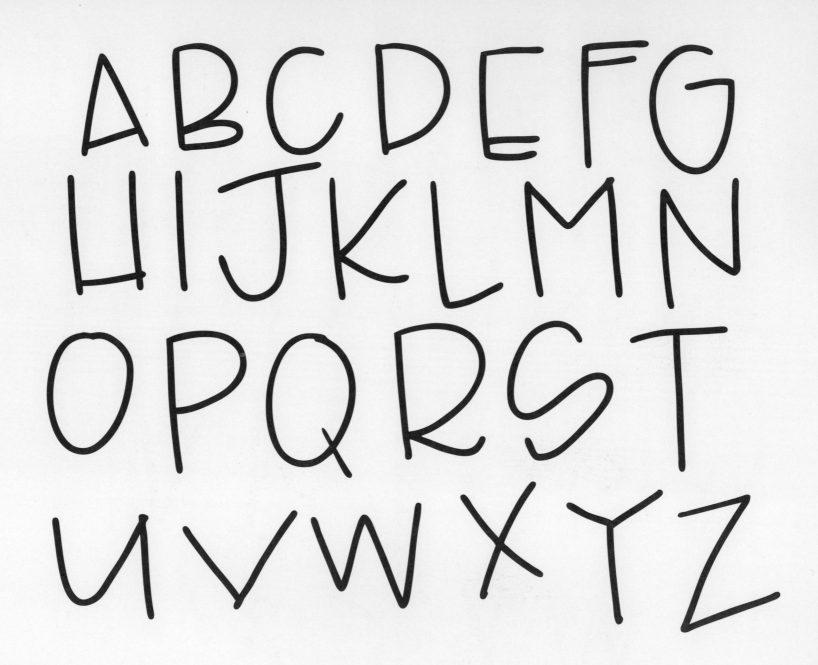

abcdefg
hijklmno
pqrstuv
wxyz

1 ALPHABET, 3 WAYS

Here is an alphabet that can easily turn into three! You will also notice that the letters can easily be manipulated by where and how you draw the cross strokes or the bodies.

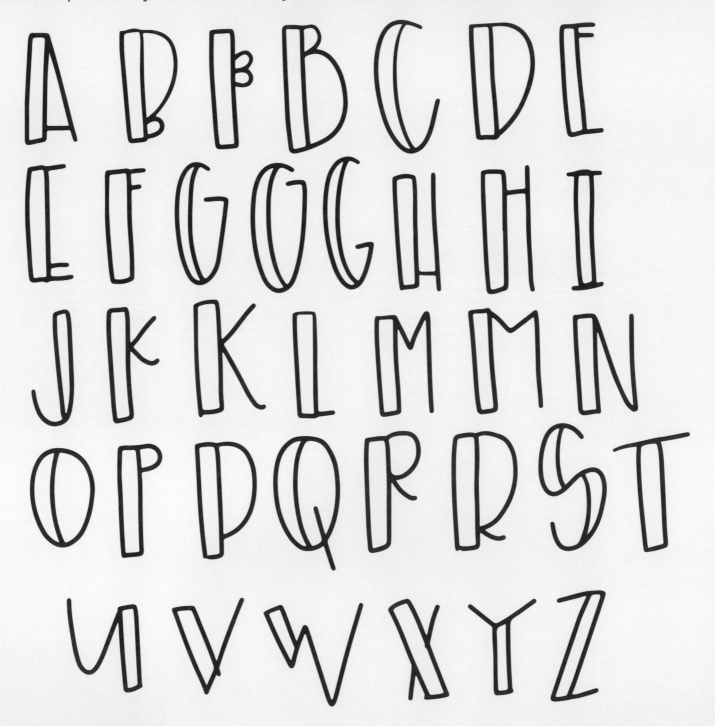

Here, I add stripes to each box part of the letter.

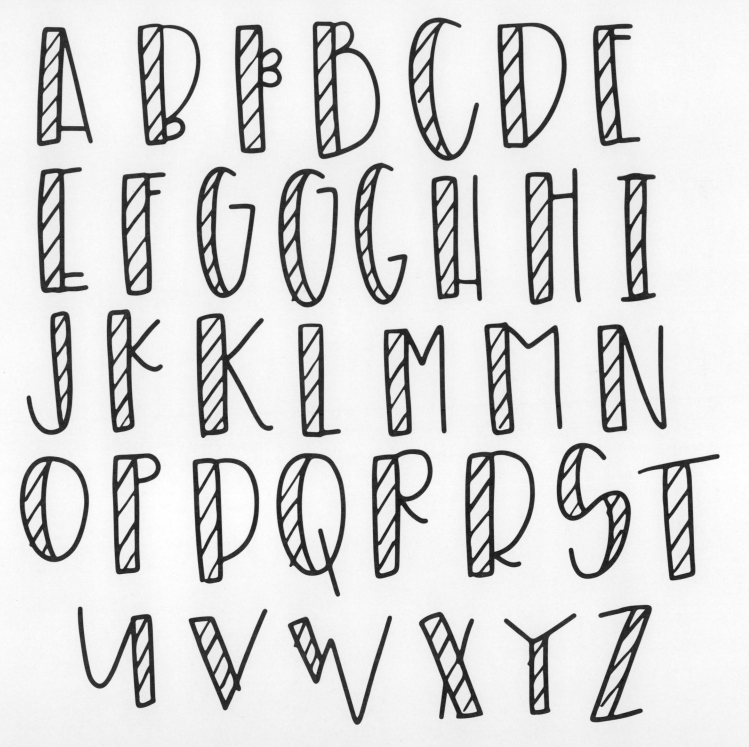

And then, I add a serif to each letter!

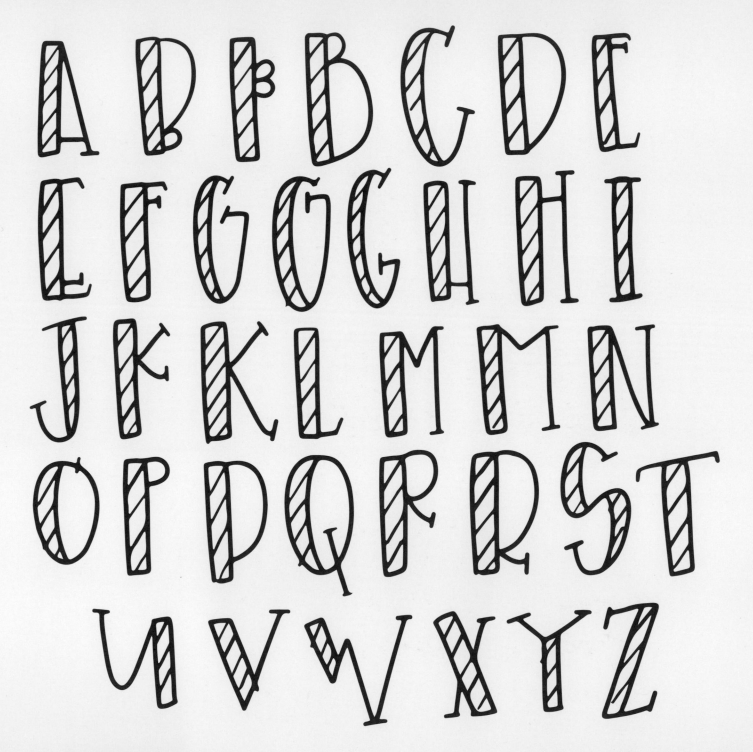

FLOURISHES AND ELEMENTS

Adding illustrations gives your design a hand drawn, whimsical feel. Some of my favorite illustrations are leaves, branches, flowers, berries, and other natural elements.

Practice here:

Flourishes can be a letterer's best friend. They can really add that special something to your design to make it feel more completed. One of my favorite designs I have done with flourishing is my "bless your heart" design. I personally tend to stear clear from over the top flourishes, because it isn't my style. Certain letterforms yield better and more natural looking flourishes than others. You can see some of my favorites illustrated below.

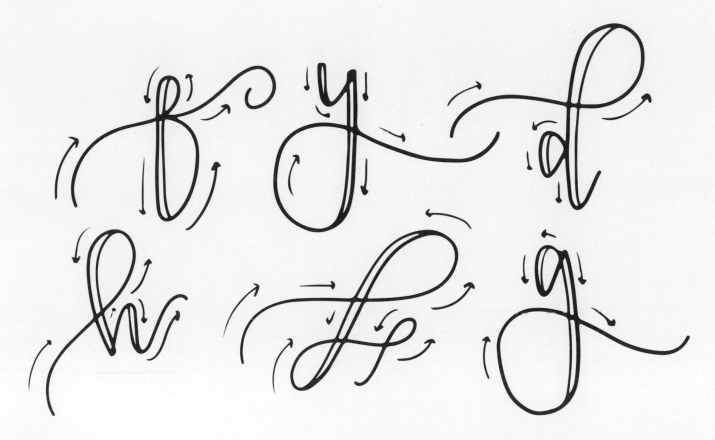

Like I mentioned before, some letterforms start or end the same, so once you master a flourish for one letter, apply it to it's counterparts. For example the Y and the G illustrated above! It is a good rule of thumb to add your flourishes to the beginning letter and ending letter of the word you are drawing! That way it looks natural and stays legible. Beware of the over flourish! I find myself running into this issue, when I get too lose or excited with my flourishes. The word may start to look like another word!

This looks a little like an E instead of the Fancy C I was going for.

And this most definitly looks like an s at the end.

To fix those issues, I made the C loop smaller as well as the flourish off the T.

Practice here:

EVOLUTION OF DESIGN

EVOLUTION OF DESIGN

Whenever I have a idea for a new design, I always hit the paper! I try to map it out to the best of my ability in my head, and then take pencil to paper for rough sketches. After I have a rough sketch, I will ink it out with my Micron pen, scan it in and live trace using Adobe Illustrator. Below, we will look at a few different designs that mix and match different types of lettering and watch exactly how I got there.

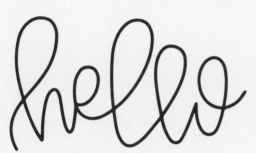

1. I draw out the word plain.

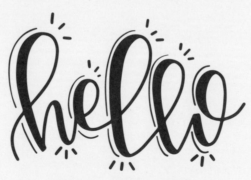

2. I add in all of my downstrokes.

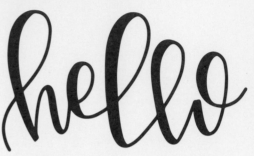

3. I fill in all of my downstrokes.

4. I add in thin strokes that outline my downstrokes for decoration.

5. I want to add more ornamental elements so I put little pops around each curve.

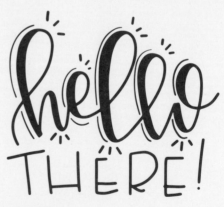

6. I add in a wide sans serif for the word "there!"

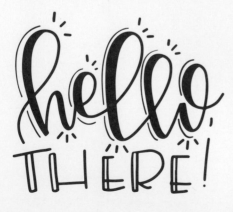

7. I want "There" to stand out more so I outline each straight line on the left side.

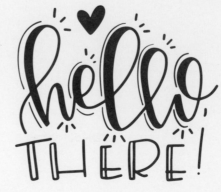

8. And for good measure, I add a little heart to some negative space between the H and the L.

1. I start with a plain word.

2. Add my downstroke.

3. Finish my phrase, but yikes. That did not work out, so I erase and center better.

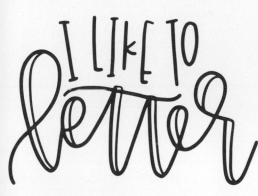

4. Much better :)

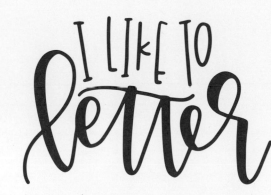

5. Fill in my downstrokes!

6. Finish the design with an illustration!

When you start developing your own style, there really isn't a rhyme or reason to designs! You don't always have to have an illustration or a flourish or elemental ornaments! You will start to recognize what draws attention to your eye and illustrate accordingly! Just have fun with it! Don't take it too seriously!

PROJECTS

PROJECT 1: BE STILL

Let's start with a simple two-word design! Start this project by tracing this design. Follow the arrows and circles for reference on where to start and finish your letters.

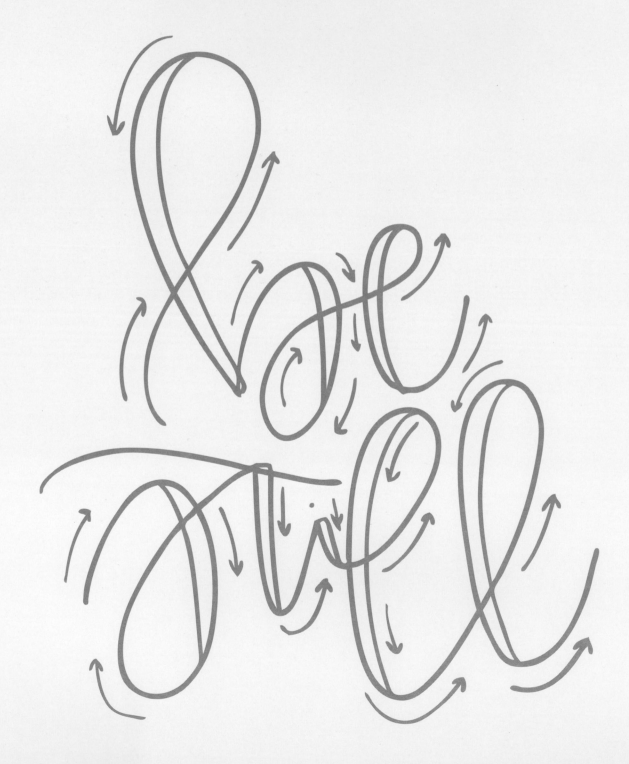

PROJECT 1: BE STILL

Use this area to try on your own!

PROJECT 2: JESUS + COFFEE

Start this project by tracing this design. Follow the arrows and circles for reference on where to start and finish your letters.

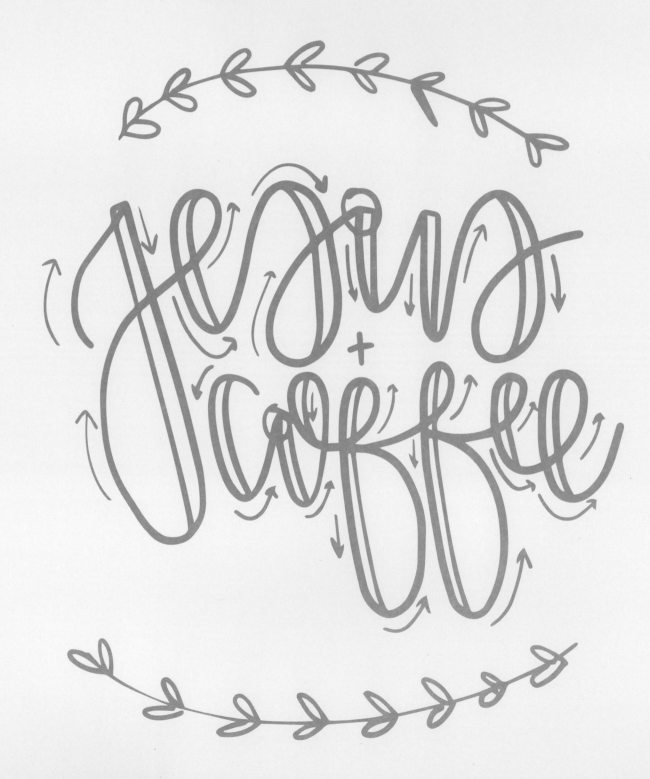

PROJECT 2: JESUS + COFFEE

Use this area to try on your own!

PROJECT 3: GET IT, GIRL

Start this project by tracing this design. Follow the arrows and circles for reference on where to start and finish your letters.

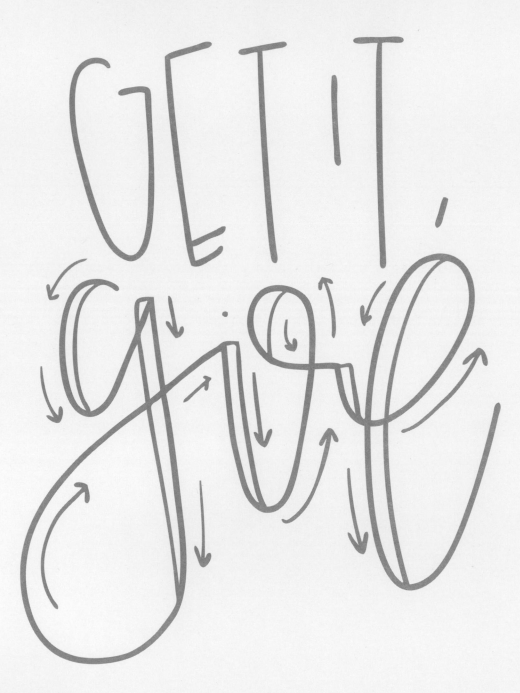

PROJECT 3: GET IT, GIRL

Use this area to try on your own!

PROJECT 4: NEVER GIVE UP

Start this project by tracing this design. Follow the arrows and circles for reference on where to start and finish your letters.

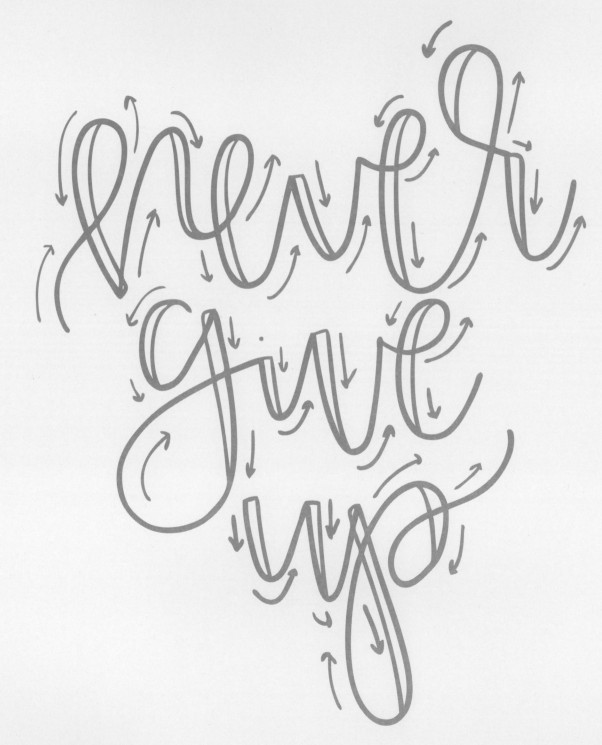

PROJECT 4: NEVER GIVE UP

Use this area to try on your own!

PROJECT 5: BUT FIRST, COFFEE

Start this project by tracing this design. Follow the arrows and circles for reference on where to start and finish your letters.

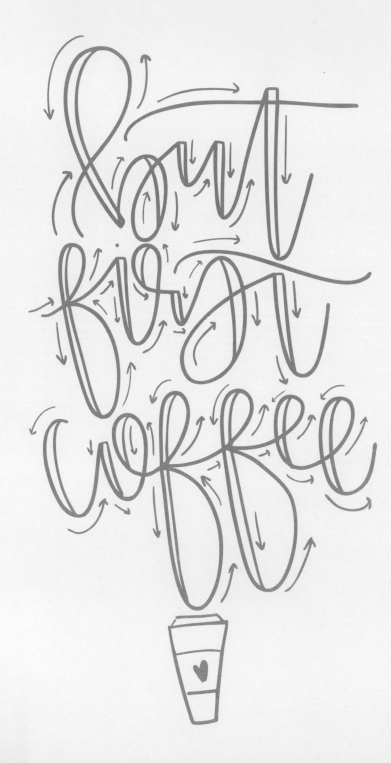

PROJECT 5: BUT FIRST, COFFEE

Use this area to try on your own!

PROJECT 6: THINK HAPPY, BE HAPPY

Start this project by tracing this design. Follow the arrows and circles for reference on where to start and finish your letters.

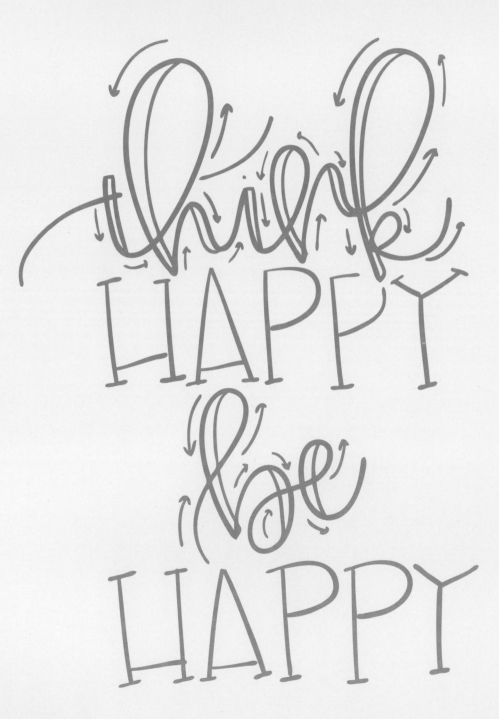

PROJECT 6: THINK HAPPY, BE HAPPY

Use this area to try on your own!

PROJECT 7: LIFE IS SWEET

Start this project by tracing this design. Follow the arrows and circles for reference on where to start and finish your letters.

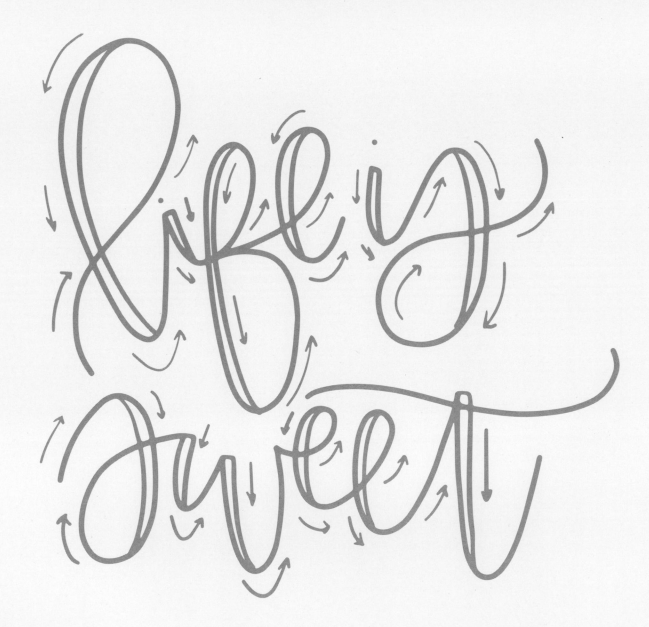

PROJECT 7: LIFE IS SWEET

Use this area to try on your own!

PROJECT 8: YOU GOT THIS

Start this project by tracing this design. Follow the arrows and circles for reference on where to start and finish your letters.

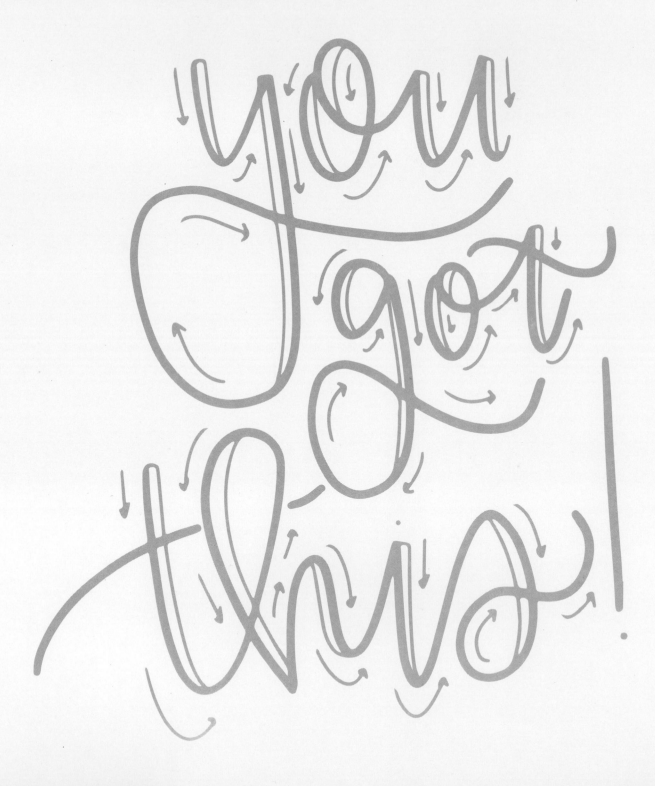

PROJECT 8: YOU GOT THIS

Use this area to try on your own!

PROJECT 9: SHINE BRIGHT

Start this project by tracing this design. Follow the arrows and circles for reference on where to start and finish your letters.

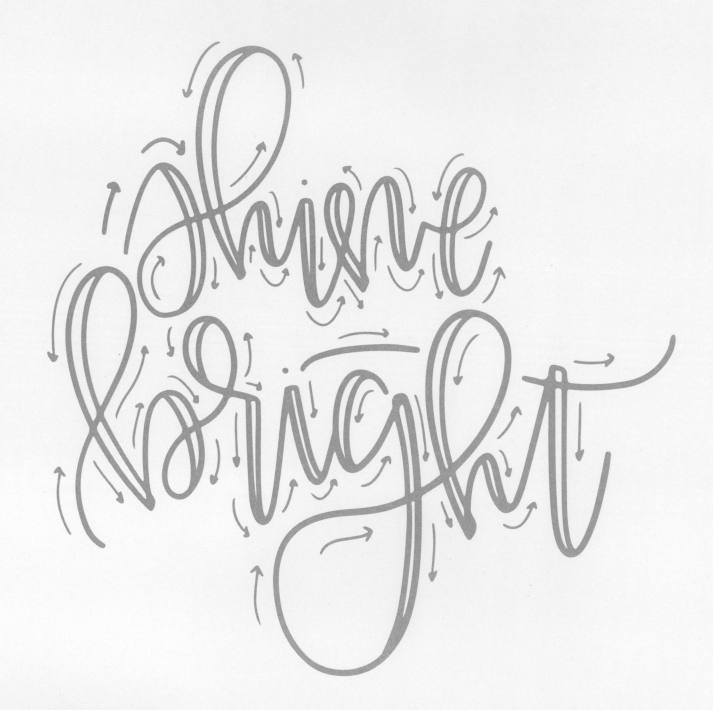

PROJECT 9: SHINE BRIGHT

Use this area to try on your own!

REFERENCE WORDS

Use these words as a reference to perfect your new skills!

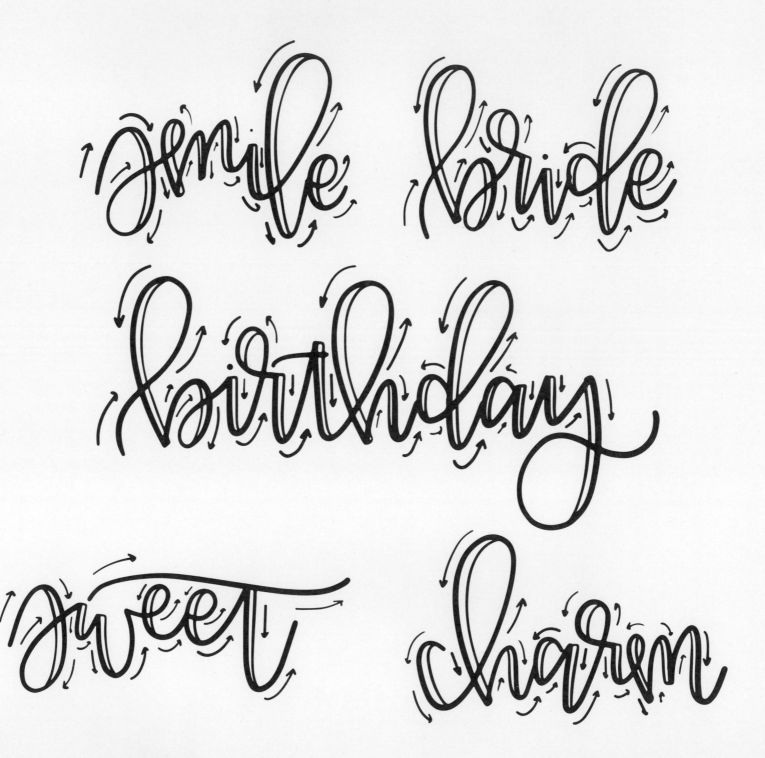

PRACTICE MAKES PERFECT

Use this space to practice!

REFERENCE WORDS

Use these words as a reference to perfect your new skills!

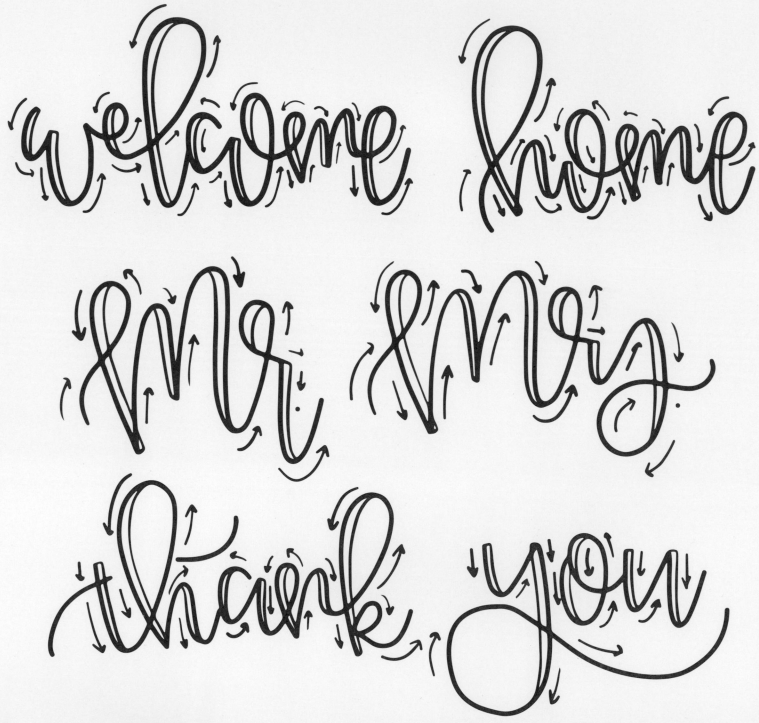

PRACTICE MAKES PERFECT

Use this space to practice!

paige tate & co.

WE ARE PASSIONATE ABOUT INSPIRING
CREATIVITY
IN EVERYONE.
WE SIMPLY PROVIDE THE BEAUTIFUL CANVAS
TO IGNITE THE
spark!

FIND ALL OF OUR PRODUCTS AT

www.paigetate.com

AND FOLLOW US ON INSTAGRAM AT

@PAIGETATEANDCO